Johanna Basford

Ivy and the Inky Butterfly

A Magical Tale to Color

Penguin Books

Introduction

Welcome to the wonderful world of Ivy and her inky butterfly, our next great coloring adventure. You can use your imagination and creativity to bring this magical story to life!

In the following pages, you're invited to follow Ivy on her quest for the inky butterfly, a journey that leads her through a secret door and into the magical world of Enchantia. From a trinket-filled treehouse to smoldering castle ruins, gargantuan gardens, and the curiosity-filled Wonder Room, there are lots of new ink-scapes to explore, color, and embellish.

I can't wait to see how you add a splash of color to this inky tale and create a book of your own!

Johanna Basford

Tips for coloring:

- Use the color palette test page at the back of this book to test your pencils and pens.

- Pencils are the most versatile medium for coloring and will allow you to mix and blend your colors.

- Pens will give you a vibrant pop of color, but don't press too hard, and remember to test them before you dive in!

- Pop a blank sheet of paper beneath the page you are working on to prevent indenting the page below and to catch any ink transfer.

- Don't worry if you go over the lines.

- Share your creations with friends or post pictures on social media with the hashtag #InkyIvy. It's fun to show off your masterpieces!

More than 200 butterflies have fluttered between the pages of this book. Can you spot them all?

This book belongs to

...

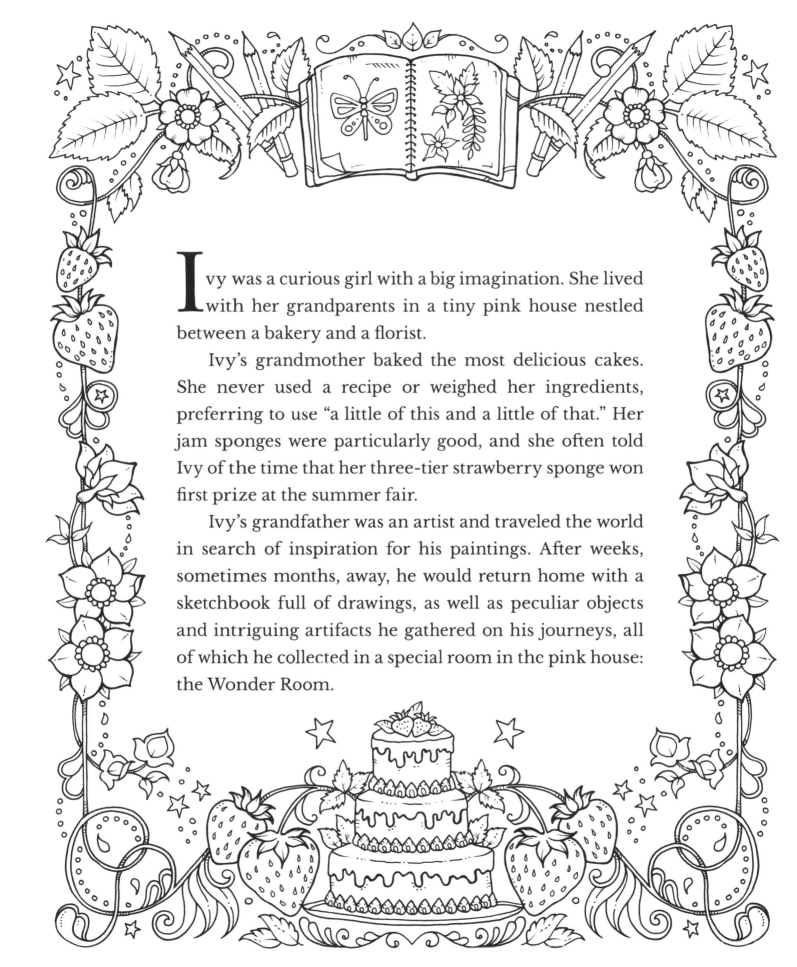

Ivy was a curious girl with a big imagination. She lived with her grandparents in a tiny pink house nestled between a bakery and a florist.

Ivy's grandmother baked the most delicious cakes. She never used a recipe or weighed her ingredients, preferring to use "a little of this and a little of that." Her jam sponges were particularly good, and she often told Ivy of the time that her three-tier strawberry sponge won first prize at the summer fair.

Ivy's grandfather was an artist and traveled the world in search of inspiration for his paintings. After weeks, sometimes months, away, he would return home with a sketchbook full of drawings, as well as peculiar objects and intriguing artifacts he gathered on his journeys, all of which he collected in a special room in the pink house: the Wonder Room.

Among the dusty treasures from his expeditions were an intricately carved cuckoo clock, a silver spoon with a handle shaped like a fish, and a tiny teapot, only as big as a thimble.

Ivy loved to examine the objects in the Wonder Room and quiz her grandfather as to where he had found them. As he sat at his desk, sharpening his pencils or examining a map, his reply was always the same: "Oh, just a little something I found on my travels," he would say with a mysterious grin. For a girl with many questions, this was a most unsatisfactory answer!

Some children enjoyed playing on swings and others preferred riding bicycles, but Ivy liked to imagine. Occasionally, though, her mind wandered a little *too* far, and she found herself glancing at darkened doorways or peering hesitantly beneath the bed, wondering whether a monster was lurking just out of sight.

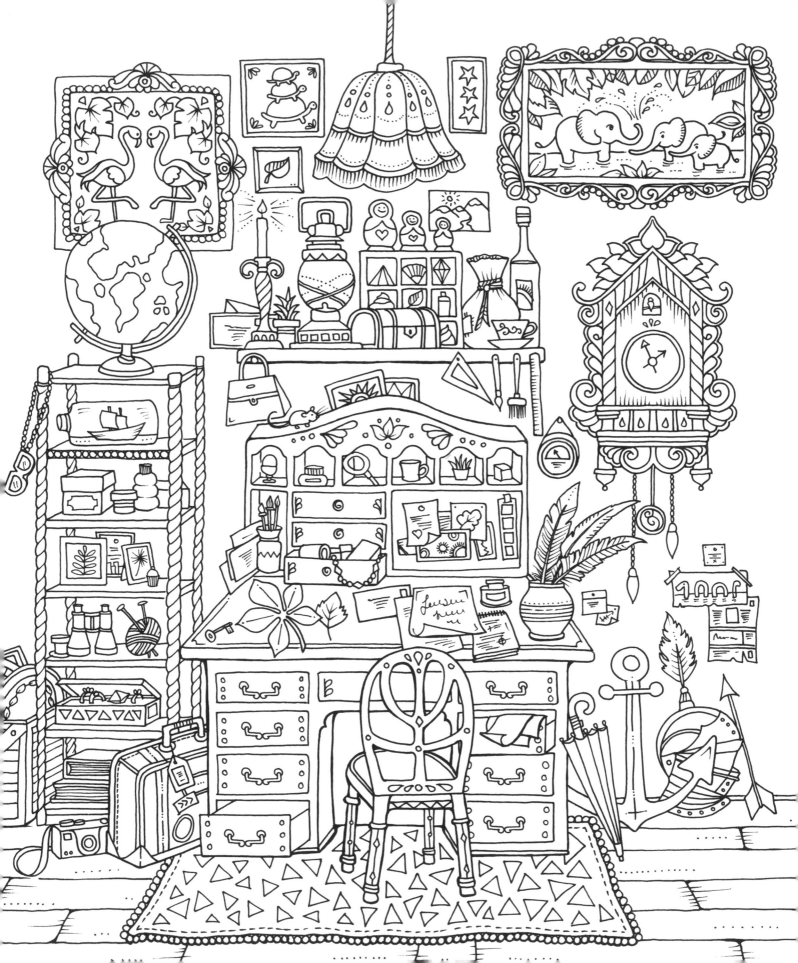

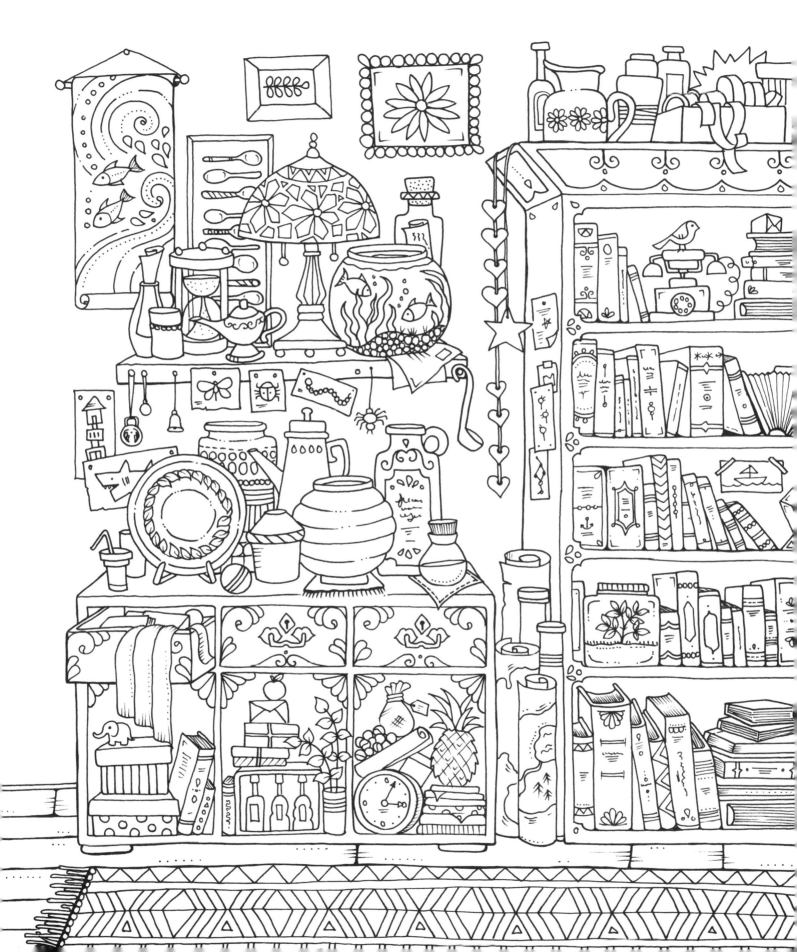

During the long, quiet weeks when her grandfather was away on his travels and her grandmother was busy in the kitchen, Ivy snuck into the Wonder Room and dreamed up histories for each item. She took great delight in deciding upon details such as where something was found and how it came to be in her grandfather's possession.

One sunny day, Ivy stood admiring her favorite painting in the Wonder Room: that of a beautiful butterfly, its wings a mosaic of dazzling colors edged in golden filigree. Unlike all the other paintings—a pair of love-struck flamingos, a family of ancient tortoises, a herd of elephants bathing in a jungle pool—the butterfly had no companion and occupied its ornate frame entirely alone.

Ivy studied the butterfly, wondering if it felt lonely or if it preferred the quiet solitude.

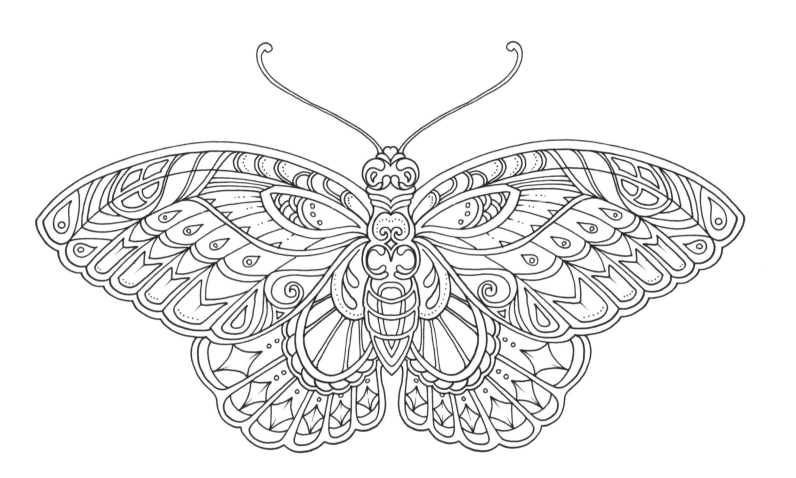

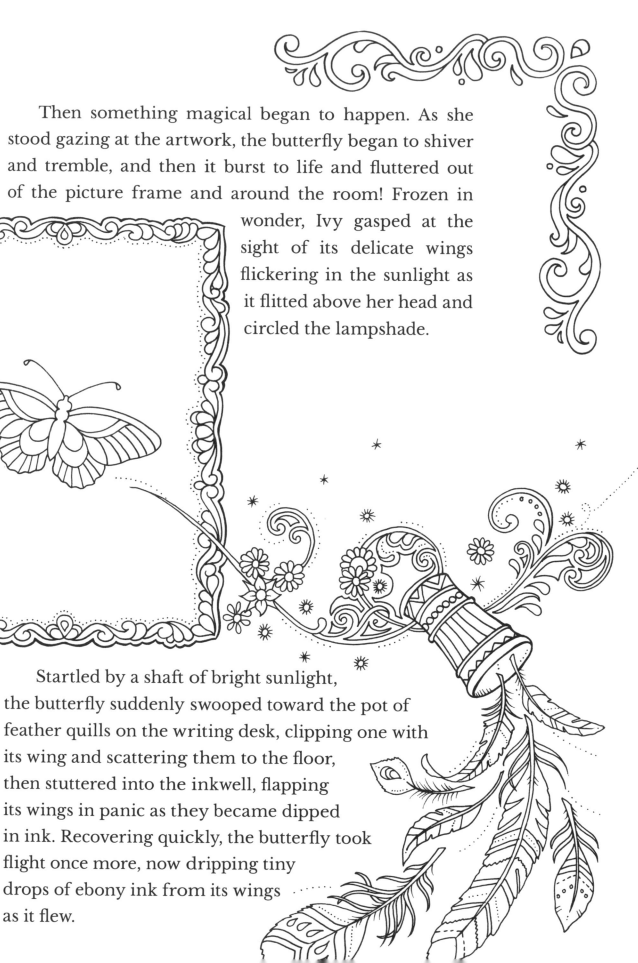

Then something magical began to happen. As she stood gazing at the artwork, the butterfly began to shiver and tremble, and then it burst to life and fluttered out of the picture frame and around the room! Frozen in wonder, Ivy gasped at the sight of its delicate wings flickering in the sunlight as it flitted above her head and circled the lampshade.

Startled by a shaft of bright sunlight, the butterfly suddenly swooped toward the pot of feather quills on the writing desk, clipping one with its wing and scattering them to the floor, then stuttered into the inkwell, flapping its wings in panic as they became dipped in ink. Recovering quickly, the butterfly took flight once more, now dripping tiny drops of ebony ink from its wings as it flew.

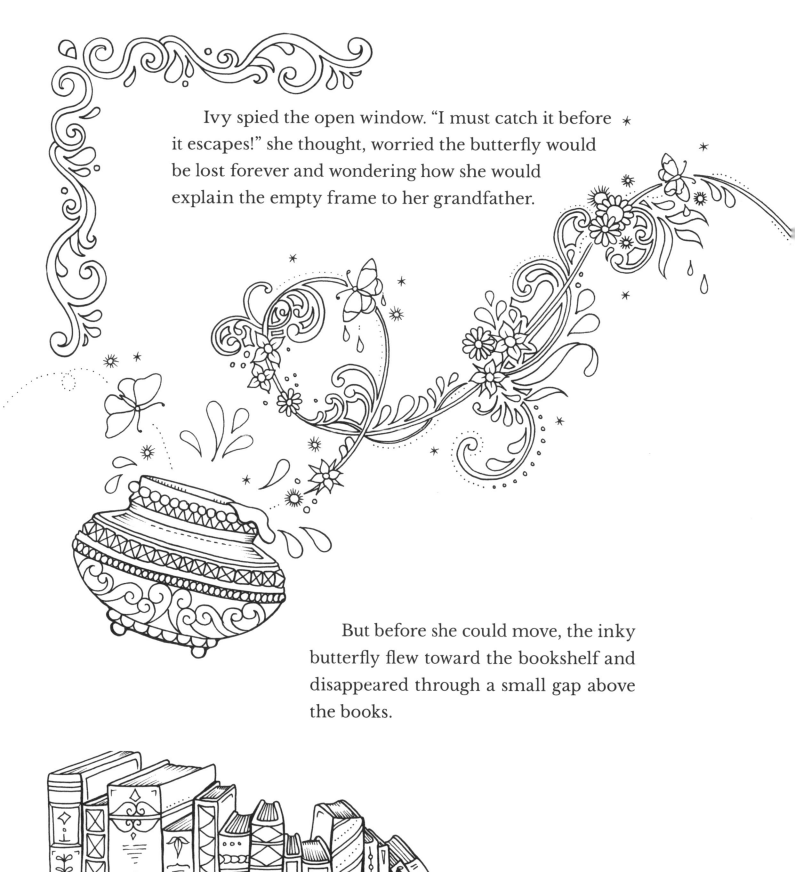

Ivy spied the open window. "I must catch it before it escapes!" she thought, worried the butterfly would be lost forever and wondering how she would explain the empty frame to her grandfather.

But before she could move, the inky butterfly flew toward the bookshelf and disappeared through a small gap above the books.

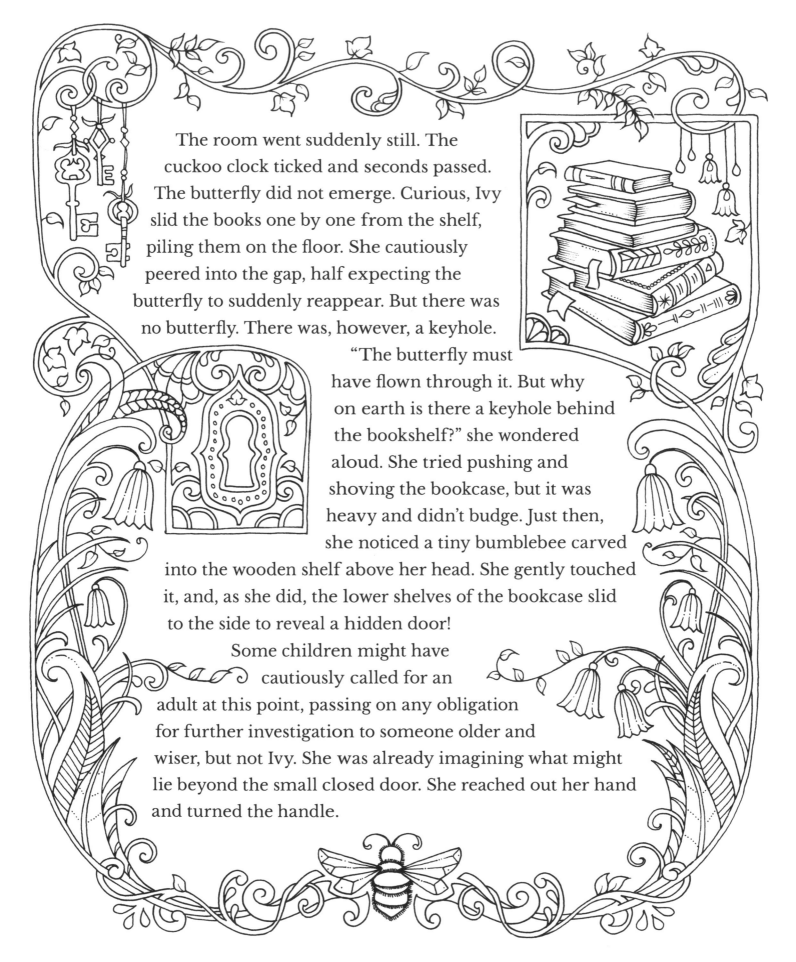

The room went suddenly still. The cuckoo clock ticked and seconds passed. The butterfly did not emerge. Curious, Ivy slid the books one by one from the shelf, piling them on the floor. She cautiously peered into the gap, half expecting the butterfly to suddenly reappear. But there was no butterfly. There was, however, a keyhole.

"The butterfly must have flown through it. But why on earth is there a keyhole behind the bookshelf?" she wondered aloud. She tried pushing and shoving the bookcase, but it was heavy and didn't budge. Just then, she noticed a tiny bumblebee carved into the wooden shelf above her head. She gently touched it, and, as she did, the lower shelves of the bookcase slid to the side to reveal a hidden door!

Some children might have cautiously called for an adult at this point, passing on any obligation for further investigation to someone older and wiser, but not Ivy. She was already imagining what might lie beyond the small closed door. She reached out her hand and turned the handle.

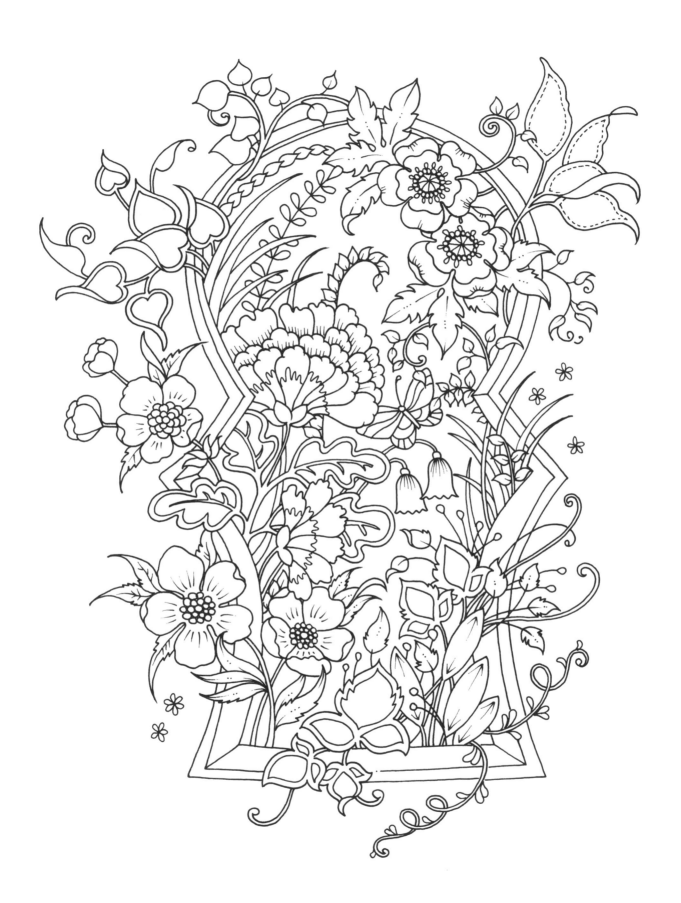

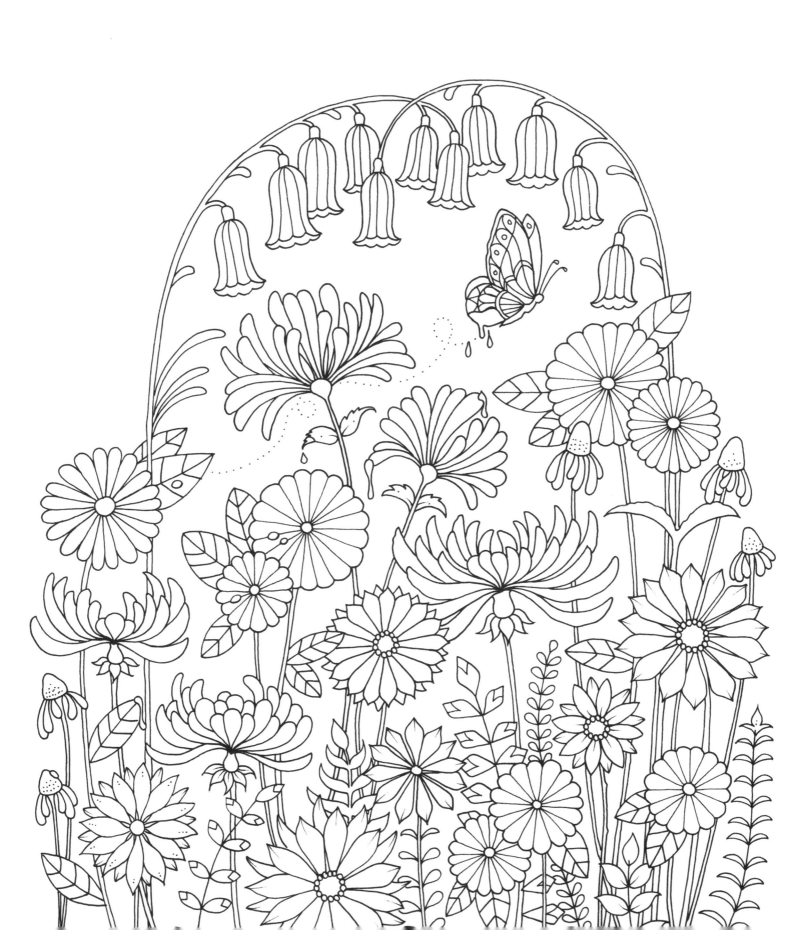

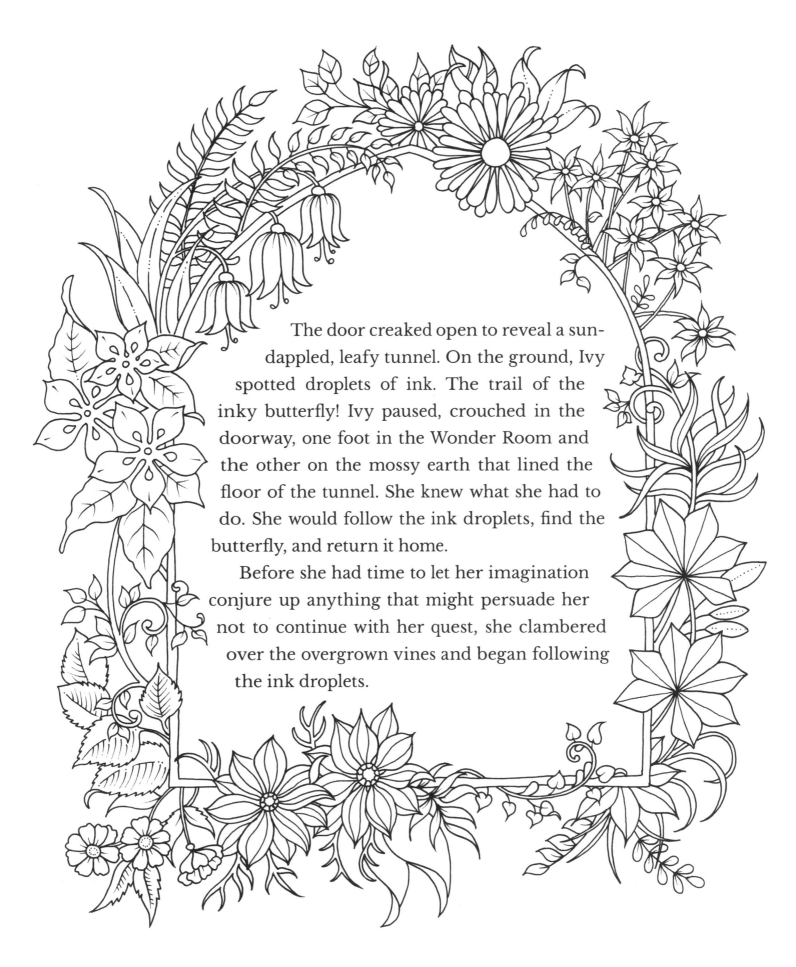

The door creaked open to reveal a sun-dappled, leafy tunnel. On the ground, Ivy spotted droplets of ink. The trail of the inky butterfly! Ivy paused, crouched in the doorway, one foot in the Wonder Room and the other on the mossy earth that lined the floor of the tunnel. She knew what she had to do. She would follow the ink droplets, find the butterfly, and return it home.

Before she had time to let her imagination conjure up anything that might persuade her not to continue with her quest, she clambered over the overgrown vines and began following the ink droplets.

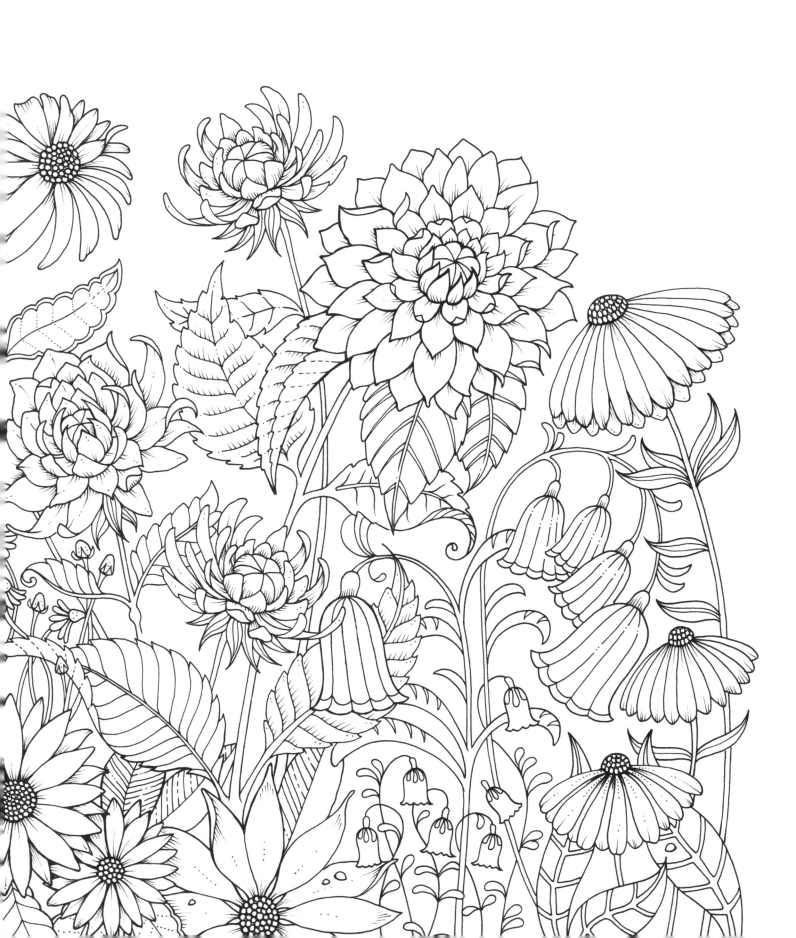

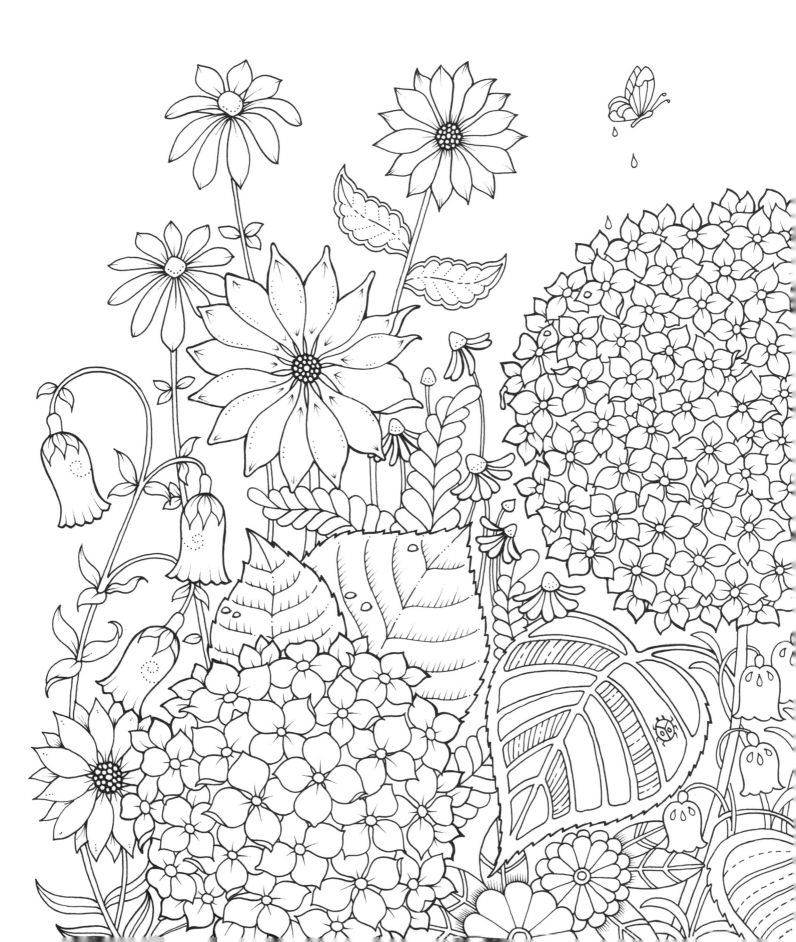

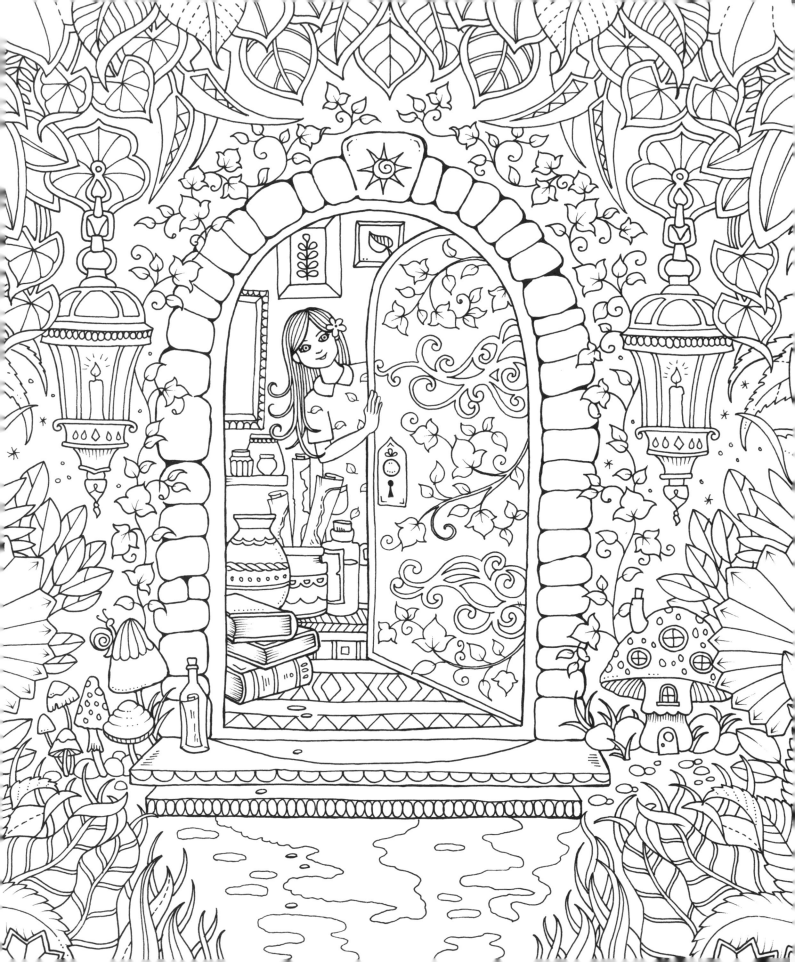

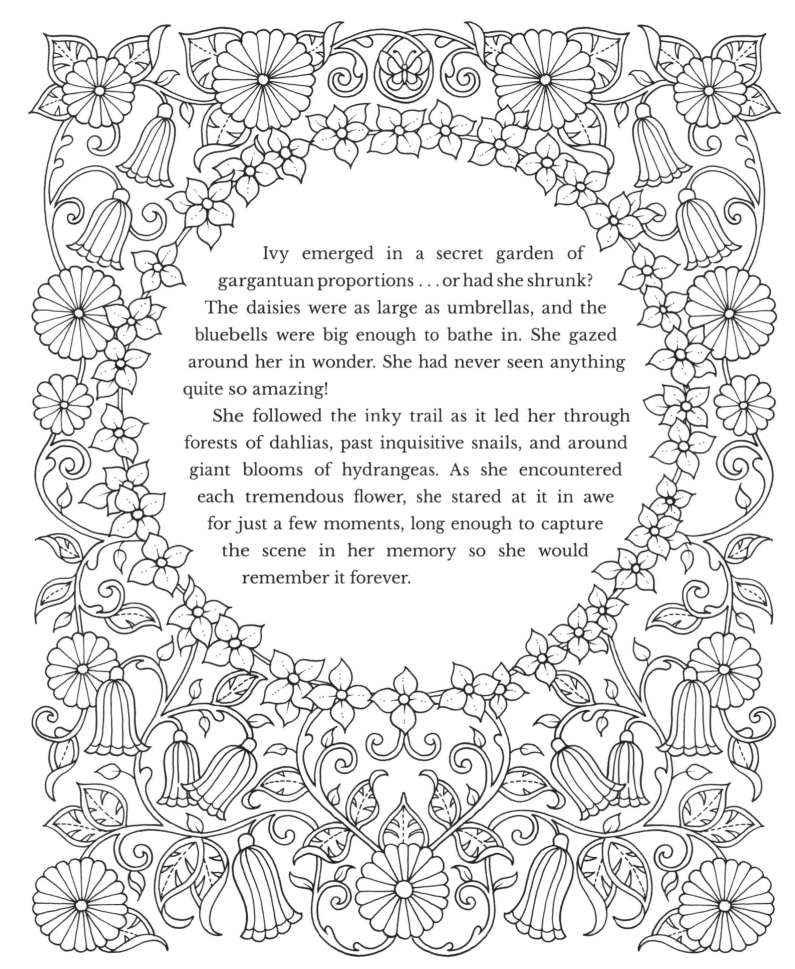

Ivy emerged in a secret garden of
gargantuan proportions . . . or had she shrunk?
The daisies were as large as umbrellas, and the
bluebells were big enough to bathe in. She gazed
around her in wonder. She had never seen anything
quite so amazing!

She followed the inky trail as it led her through
forests of dahlias, past inquisitive snails, and around
giant blooms of hydrangeas. As she encountered
each tremendous flower, she stared at it in awe
for just a few moments, long enough to capture
the scene in her memory so she would
remember it forever.

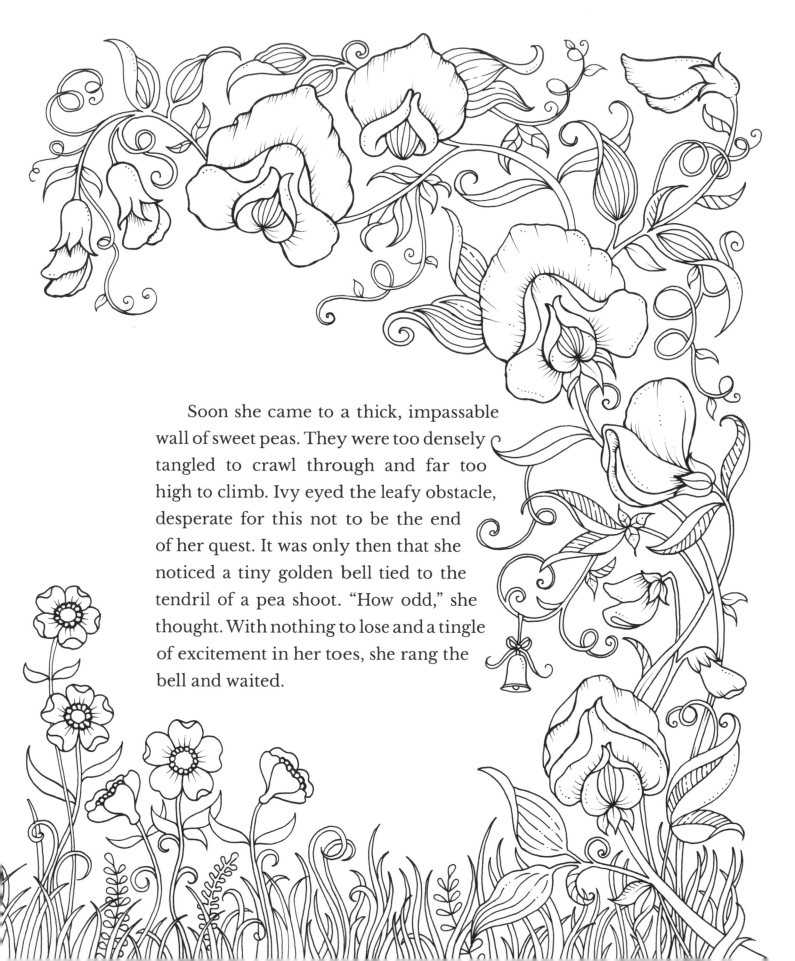

Soon she came to a thick, impassable wall of sweet peas. They were too densely tangled to crawl through and far too high to climb. Ivy eyed the leafy obstacle, desperate for this not to be the end of her quest. It was only then that she noticed a tiny golden bell tied to the tendril of a pea shoot. "How odd," she thought. With nothing to lose and a tingle of excitement in her toes, she rang the bell and waited.

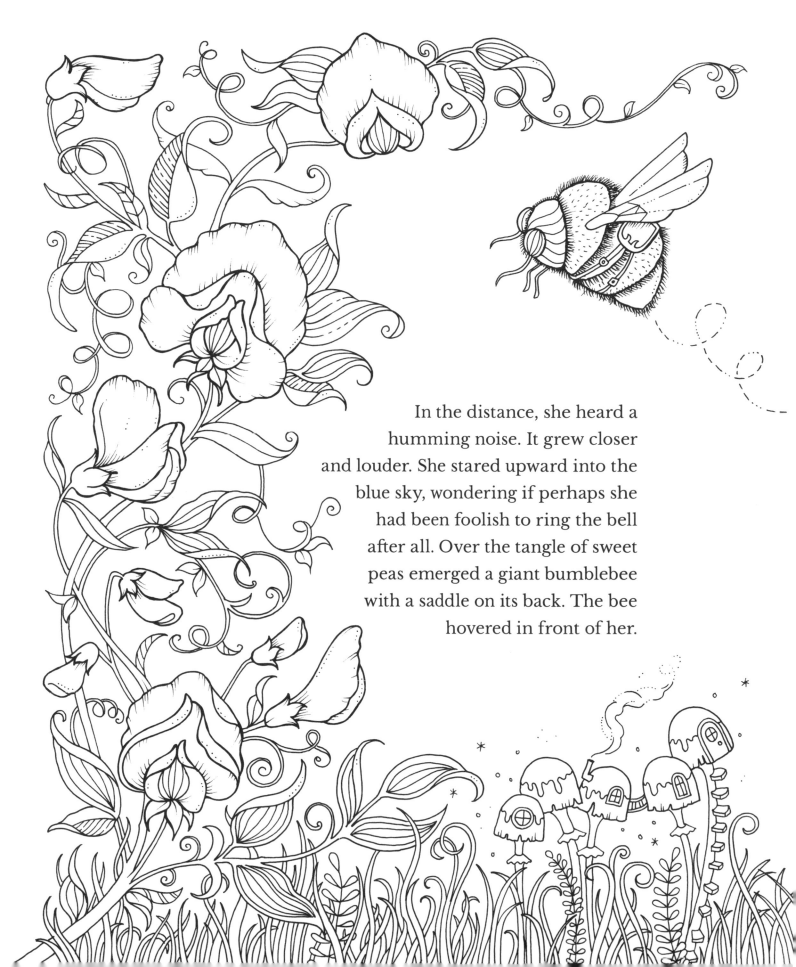

In the distance, she heard a humming noise. It grew closer and louder. She stared upward into the blue sky, wondering if perhaps she had been foolish to ring the bell after all. Over the tangle of sweet peas emerged a giant bumblebee with a saddle on its back. The bee hovered in front of her.

Ivy didn't like to ask for help, but at this point she realized the bee might be her only option. She quickly decided that when faced with a giant insect of any species, it was probably best to be polite but firm, so as not to give the impression you were in the slightest bit wary and allow the insect the upper hand.

"Hello. My name is Ivy," she said, addressing the bee with as much authority as she could muster. "I'm following this trail, which will lead me to my butterfly." She gestured to the line of ink drops at her feet. "Can you please help me?"

The bee buzzed in apparent agreement, settling on the ground so she could climb on.

Ivy paused. She had once seen a girl from school riding a pony at the town fair, clinging onto its mane and screaming for her mother, and had thought it looked dangerous and unpleasant (for both the girl and the pony). Not being inclined to equestrian pursuits herself, bee riding seemed ambitious. Nevertheless, she had to follow the inky trail. She pushed visions of being thrown from the saddle or tumbling headfirst into the daisies below from her mind.

Cautiously, Ivy scrambled onto the bee's back.

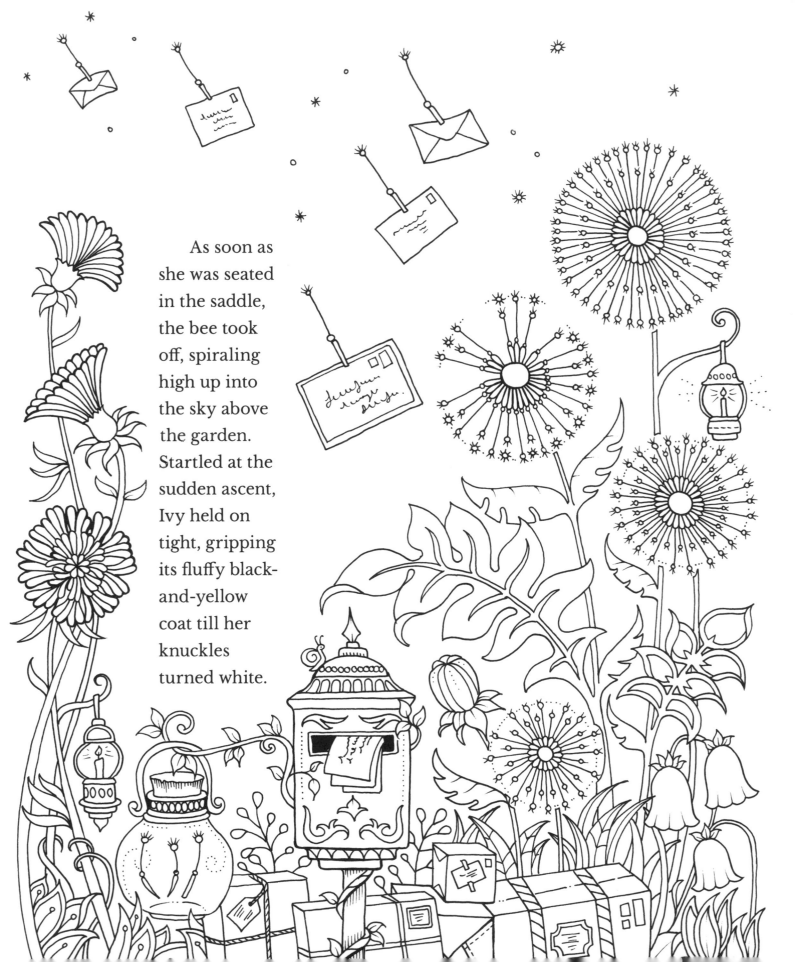

As soon as she was seated in the saddle, the bee took off, spiraling high up into the sky above the garden. Startled at the sudden ascent, Ivy held on tight, gripping its fluffy black-and-yellow coat till her knuckles turned white.

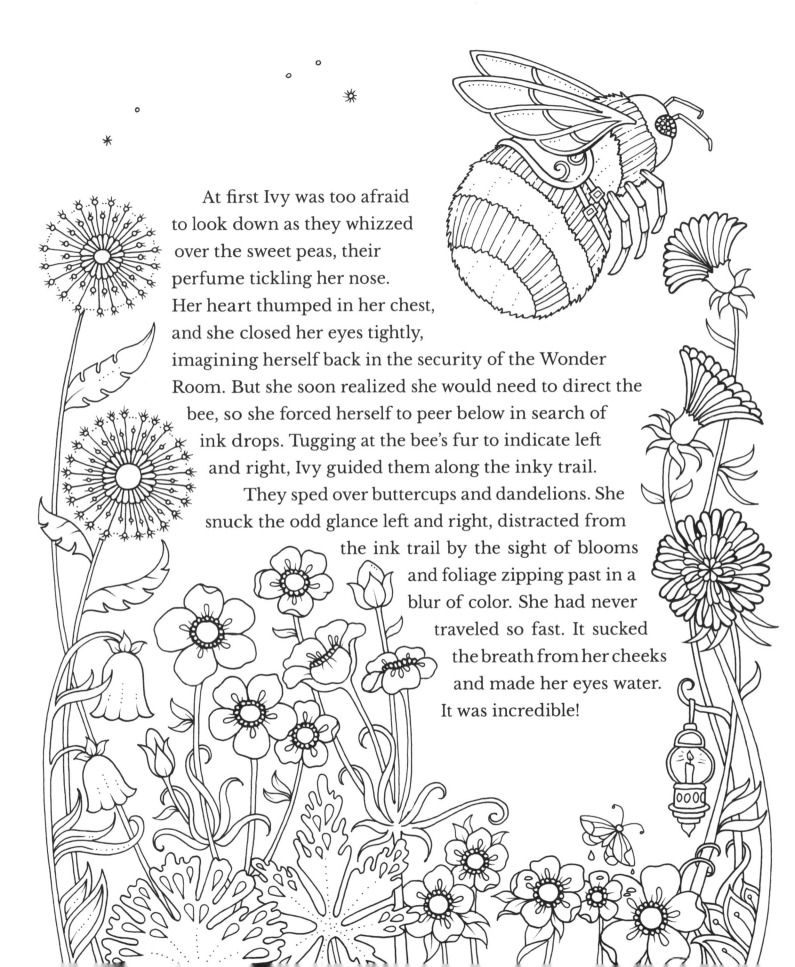

At first Ivy was too afraid
to look down as they whizzed
over the sweet peas, their
perfume tickling her nose.
Her heart thumped in her chest,
and she closed her eyes tightly,
imagining herself back in the security of the Wonder
Room. But she soon realized she would need to direct the
bee, so she forced herself to peer below in search of
ink drops. Tugging at the bee's fur to indicate left
and right, Ivy guided them along the inky trail.
They sped over buttercups and dandelions. She
snuck the odd glance left and right, distracted from
the ink trail by the sight of blooms
and foliage zipping past in a
blur of color. She had never
traveled so fast. It sucked
the breath from her cheeks
and made her eyes water.
It was incredible!

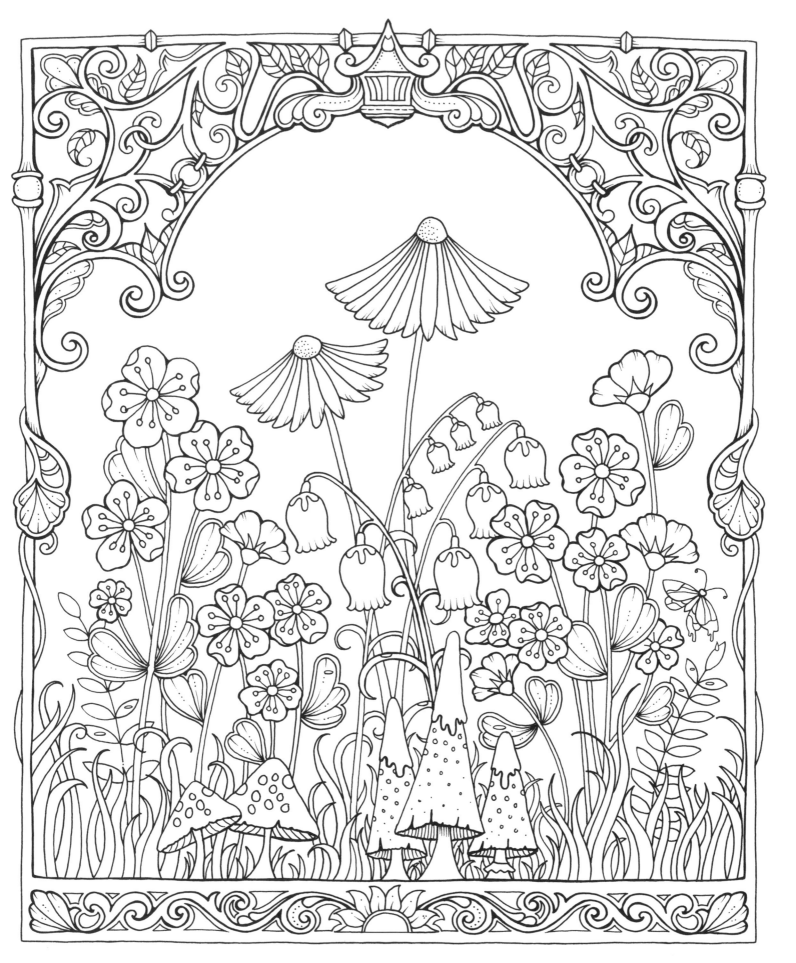

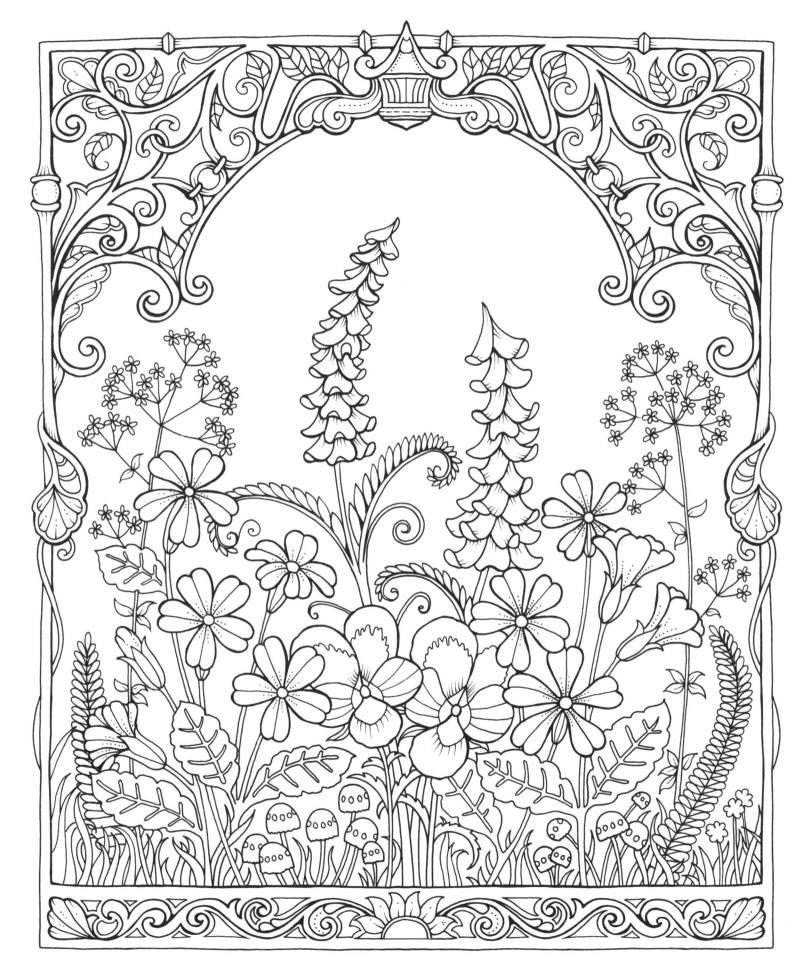

They followed the line of ink droplets out of the
garden, past thorny rosebushes, and through the branches
of a cherry blossom, until, finally, they landed in a wild-
flower meadow where the inky trail came to an abrupt
end.

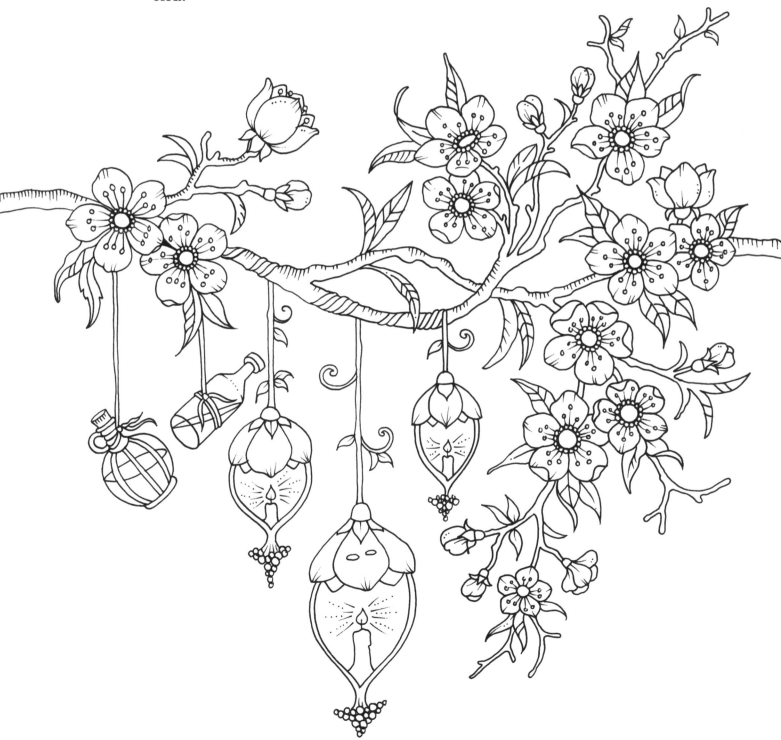

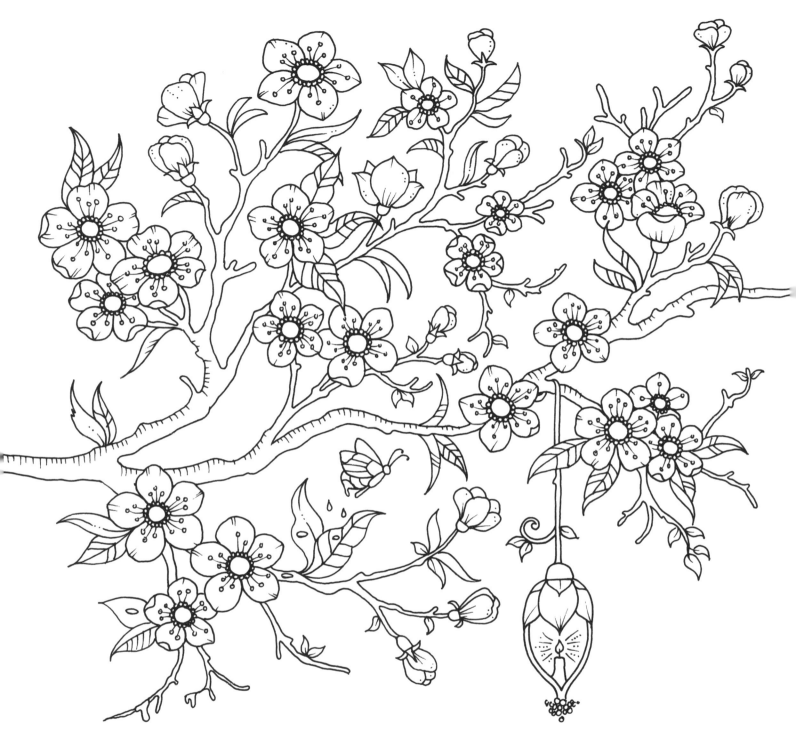

"Thank you for all your help," Ivy said to the bee, "but I think I'll have to go on alone from here."

The bee buzzed, acknowledging his dismissal, and flew up into the sky.

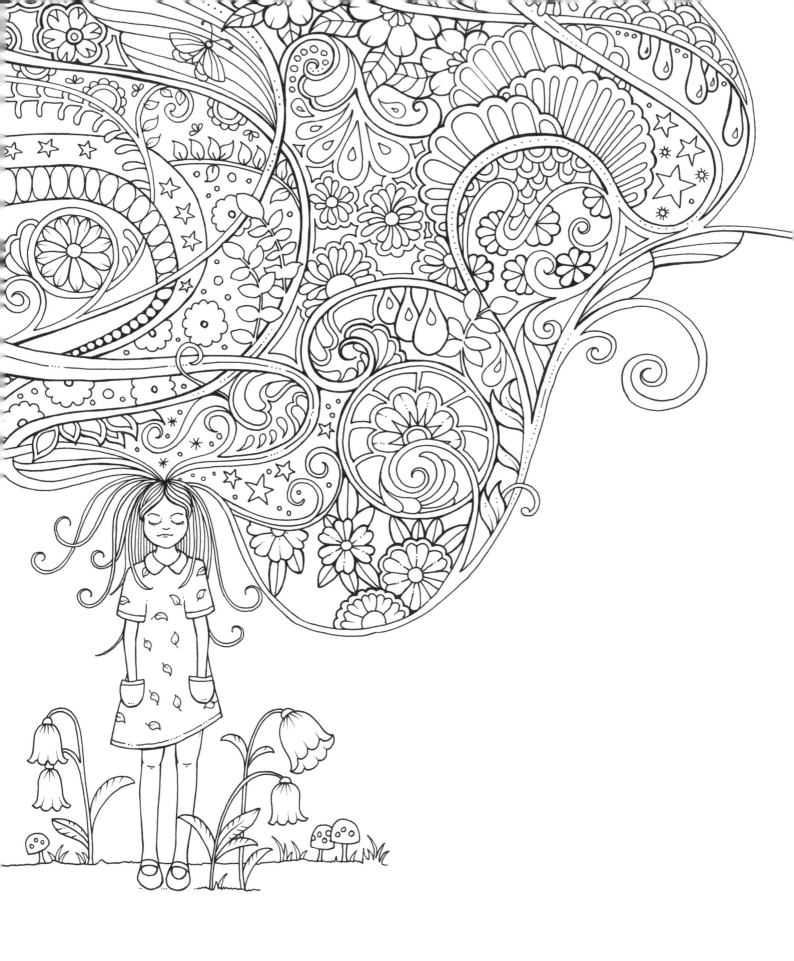

Ivy stared at the ink drops on the dusty ground. How could the ink trail just end like that? It really was most mysterious, but, luckily, Ivy loved a puzzle. She plunged her hands deep into her pockets, as she did whenever she was thinking, and imagined the possibilities, happy to be alone again so she could mull things over quietly. She was so deep in thought that at first she did not notice the mouse, which was only slightly smaller than Ivy, scurrying into the clearing.

"So much to clean in the meadow today!" the little mouse squeaked as she scrubbed at the last of the ink drops with a cloth from her apron pocket. Ivy's eyes widened as she realized what must have happened to her ink trail.

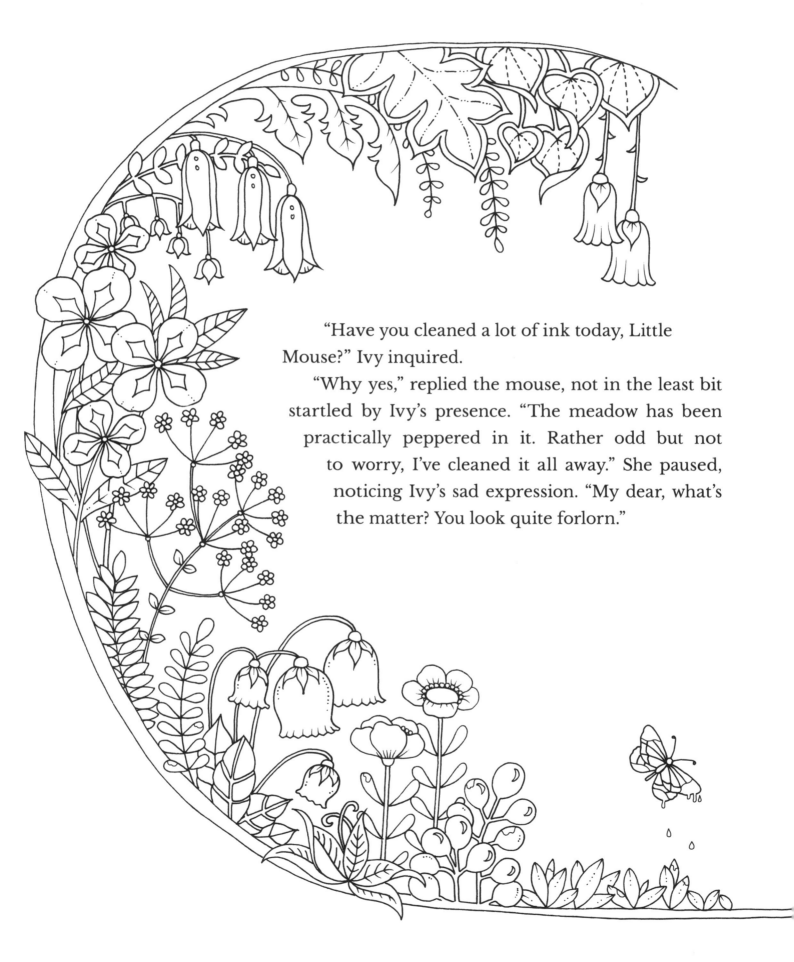

"Have you cleaned a lot of ink today, Little Mouse?" Ivy inquired.

"Why yes," replied the mouse, not in the least bit startled by Ivy's presence. "The meadow has been practically peppered in it. Rather odd but not to worry, I've cleaned it all away." She paused, noticing Ivy's sad expression. "My dear, what's the matter? You look quite forlorn."

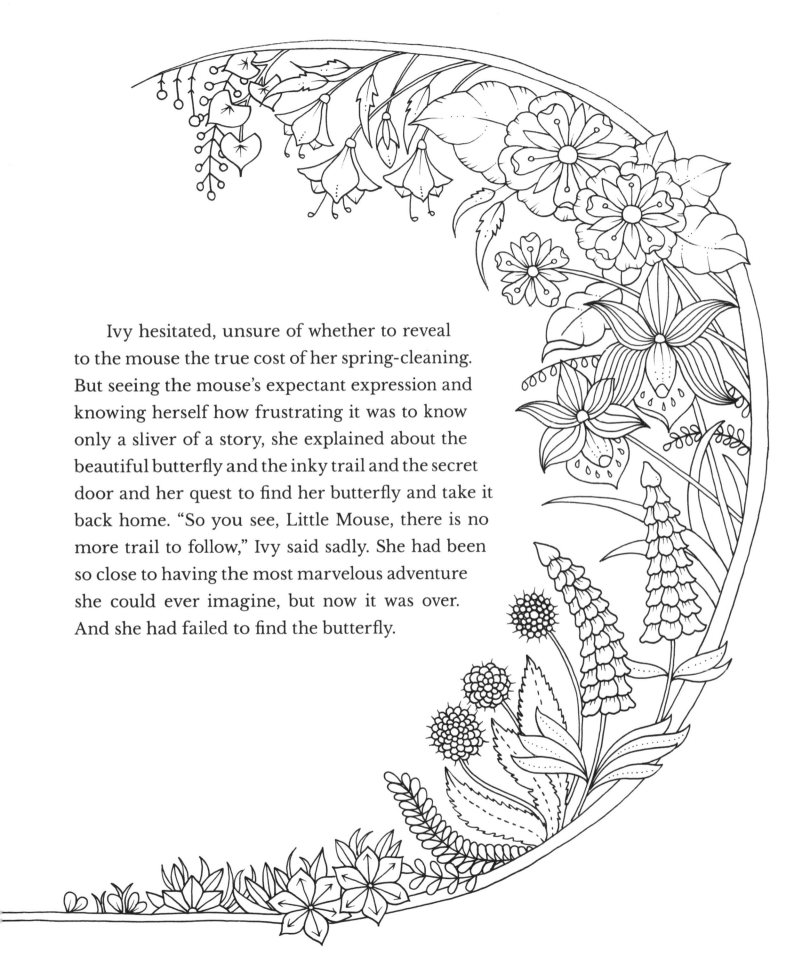

Ivy hesitated, unsure of whether to reveal to the mouse the true cost of her spring-cleaning. But seeing the mouse's expectant expression and knowing herself how frustrating it was to know only a sliver of a story, she explained about the beautiful butterfly and the inky trail and the secret door and her quest to find her butterfly and take it back home. "So you see, Little Mouse, there is no more trail to follow," Ivy said sadly. She had been so close to having the most marvelous adventure she could ever imagine, but now it was over. And she had failed to find the butterfly.

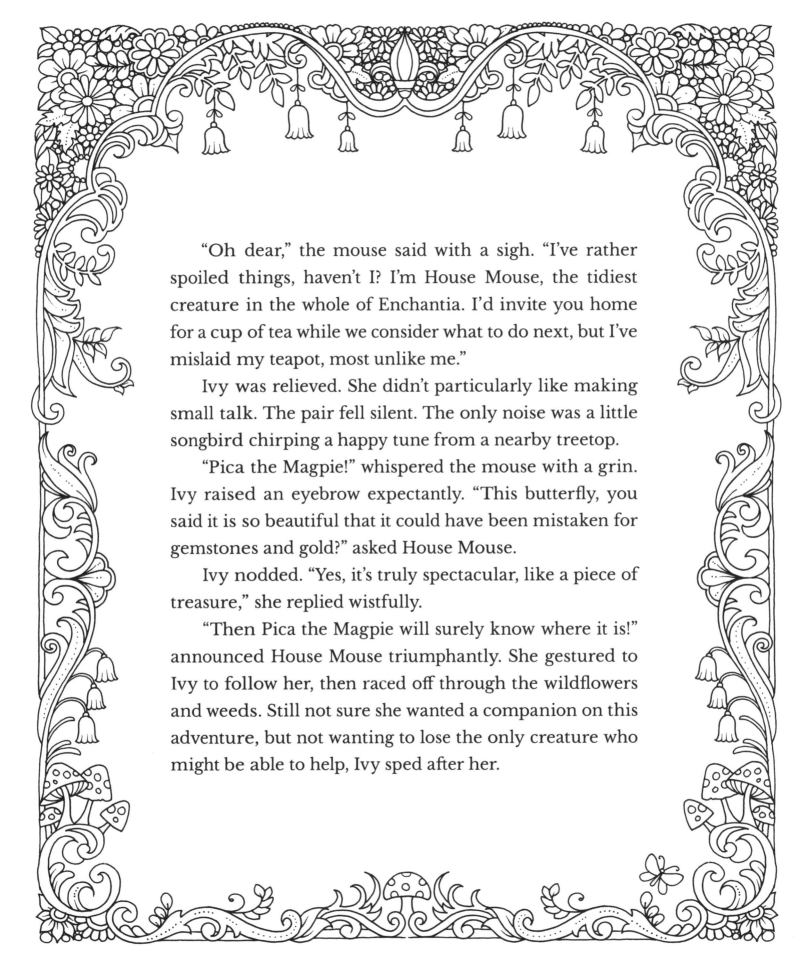

"Oh dear," the mouse said with a sigh. "I've rather spoiled things, haven't I? I'm House Mouse, the tidiest creature in the whole of Enchantia. I'd invite you home for a cup of tea while we consider what to do next, but I've mislaid my teapot, most unlike me."

Ivy was relieved. She didn't particularly like making small talk. The pair fell silent. The only noise was a little songbird chirping a happy tune from a nearby treetop.

"Pica the Magpie!" whispered the mouse with a grin. Ivy raised an eyebrow expectantly. "This butterfly, you said it is so beautiful that it could have been mistaken for gemstones and gold?" asked House Mouse.

Ivy nodded. "Yes, it's truly spectacular, like a piece of treasure," she replied wistfully.

"Then Pica the Magpie will surely know where it is!" announced House Mouse triumphantly. She gestured to Ivy to follow her, then raced off through the wildflowers and weeds. Still not sure she wanted a companion on this adventure, but not wanting to lose the only creature who might be able to help, Ivy sped after her.

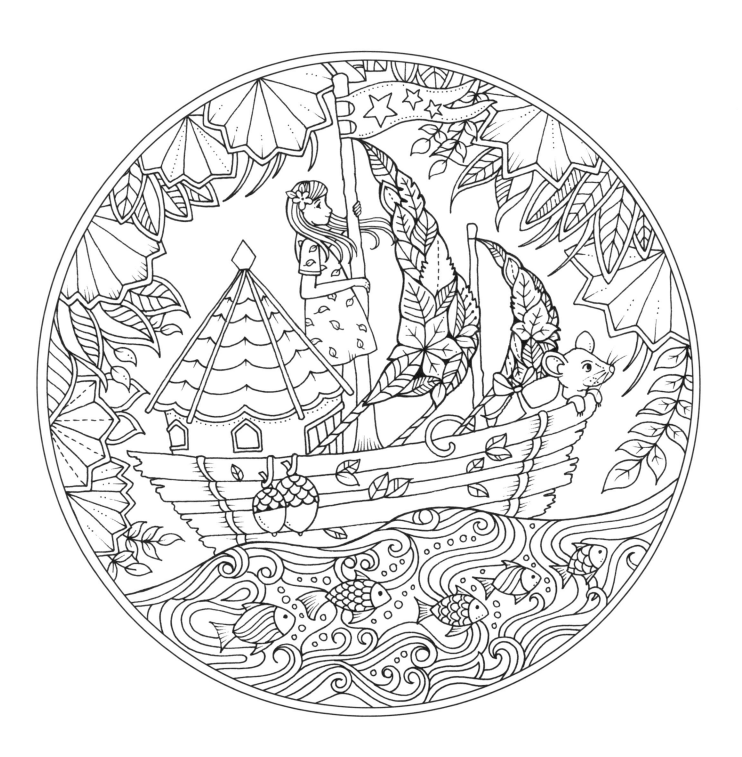

Arriving at the side of a stream, House Mouse instructed Ivy to wait and then disappeared beneath some large, shady ferns. She reappeared on a small wooden raft with sails made of leaves. She steered it alongside the bank. "Quick, jump!" she shouted, holding out her little paw to Ivy. "It's OK; I can manage by myself," replied Ivy, awkwardly scrambling aboard.

They sailed quietly down the stream, gently bobbing as the water rippled over large pebbles and around fallen trees.

Ivy peered into the water below for any sign of underwater danger, territorial mermaids, hungry piranhas . . . but, to her relief, saw none. Soon she was too distracted by giant lily pads and fat frogs, stilted water dwellings and lazy herons, to worry about watery perils.

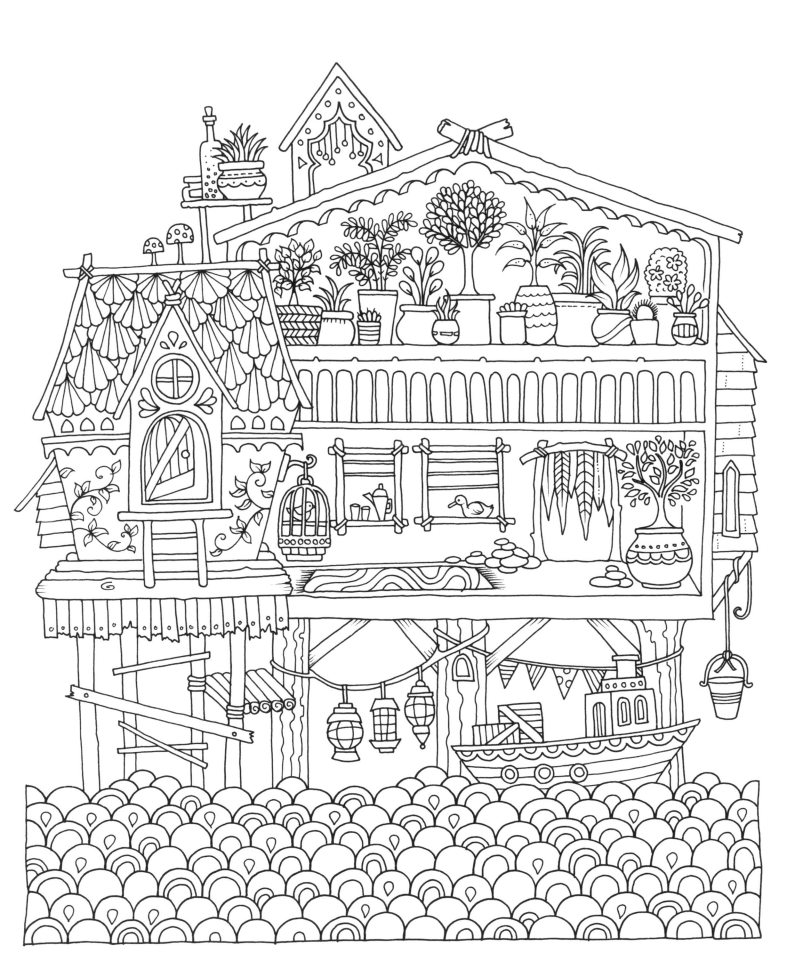

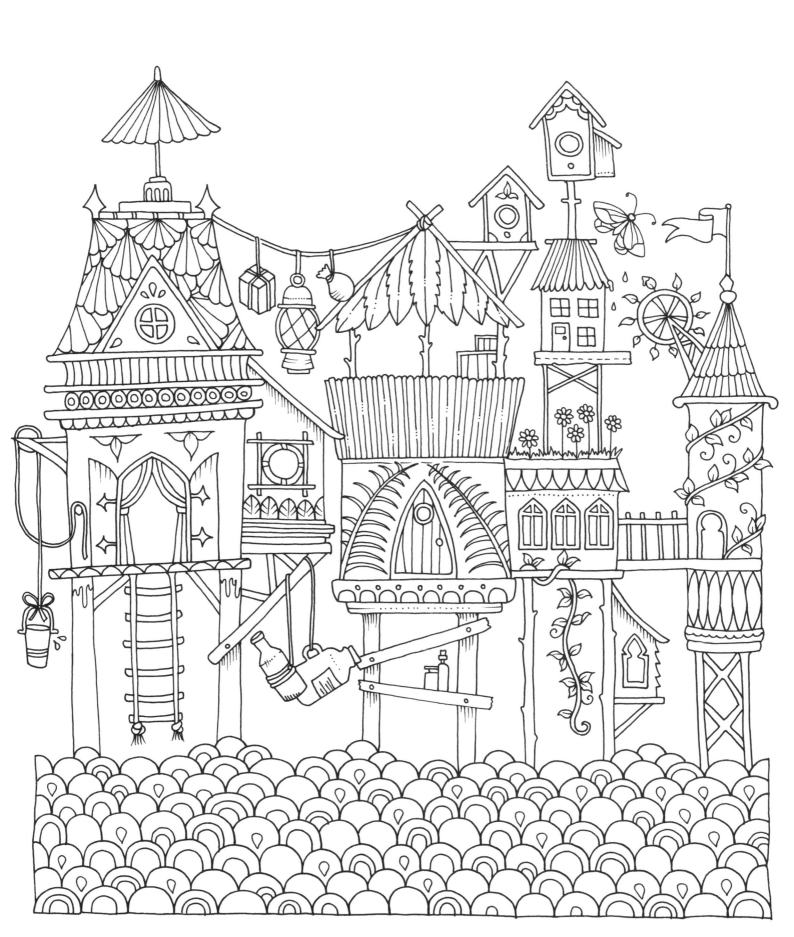

As they traveled, House Mouse explained that Pica was an old magpie who lived in a tree house, high up in the forest. He collected treasures from all over Enchantia: golden coins and mislaid crowns, glittering necklaces and silver spoons. House Mouse was sure that Pica spotted the butterfly and took it home to clean off the remaining smudges of ink. "Restoring treasures to their former glory is his passion," explained House Mouse with a wink.

Ivy nodded, glancing at House Mouse, who was peering downstream, on the lookout for Pica's home. Ivy wasn't entirely sure she trusted the mouse or her magpie friend, but what option did she have? The inky trail was gone.

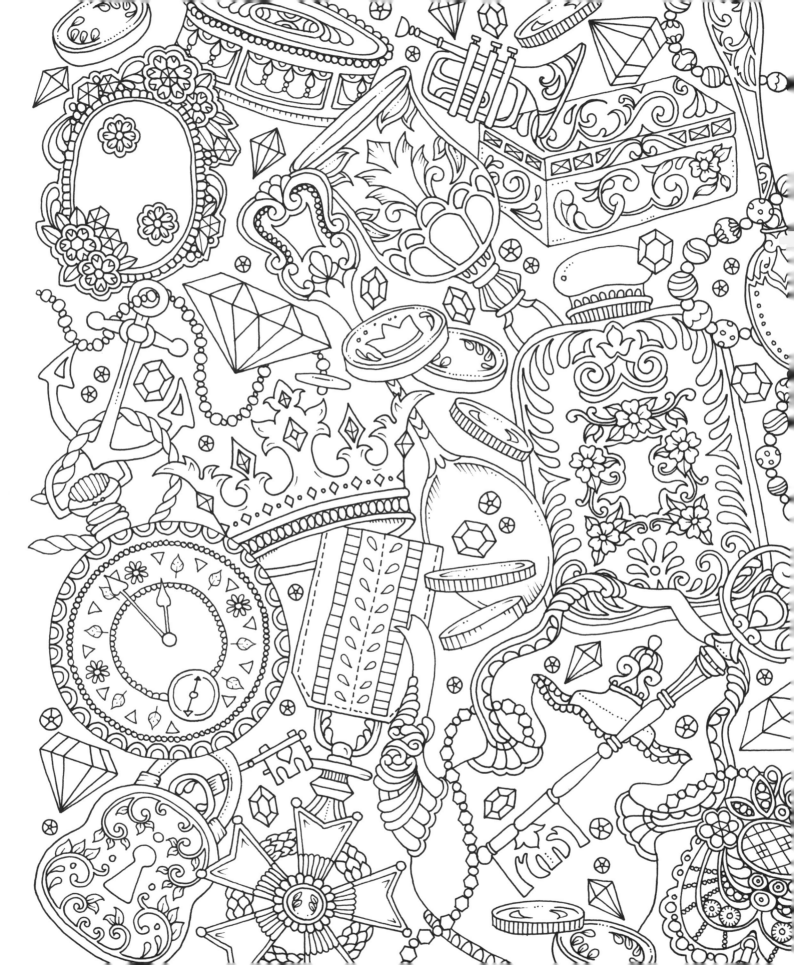

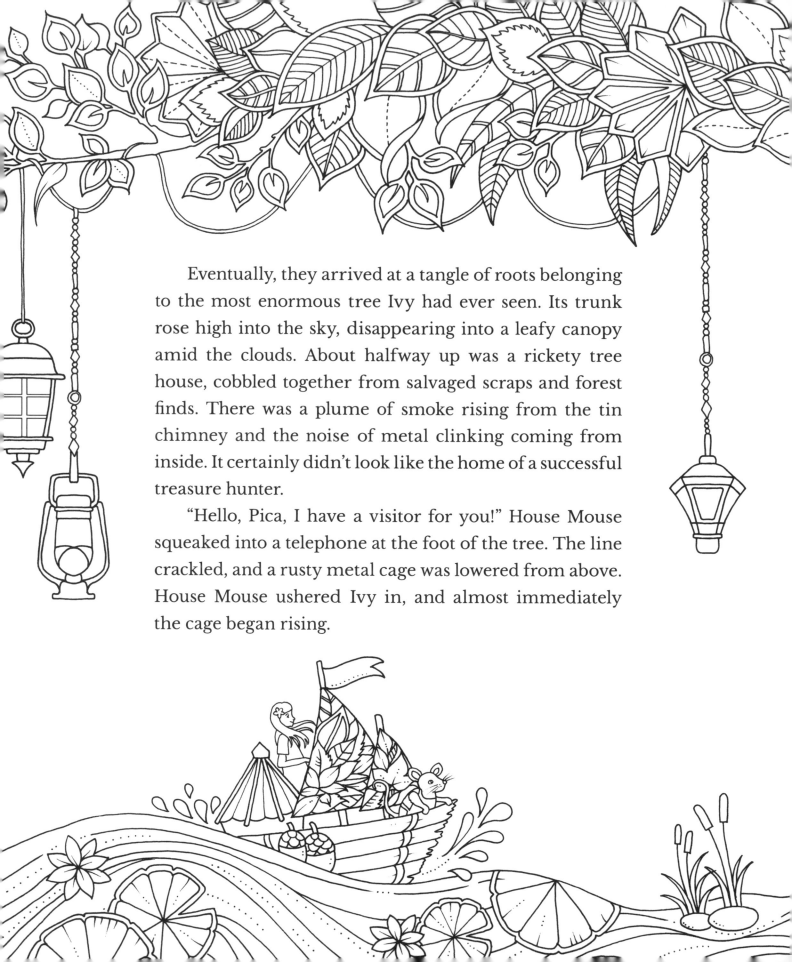

Eventually, they arrived at a tangle of roots belonging to the most enormous tree Ivy had ever seen. Its trunk rose high into the sky, disappearing into a leafy canopy amid the clouds. About halfway up was a rickety tree house, cobbled together from salvaged scraps and forest finds. There was a plume of smoke rising from the tin chimney and the noise of metal clinking coming from inside. It certainly didn't look like the home of a successful treasure hunter.

"Hello, Pica, I have a visitor for you!" House Mouse squeaked into a telephone at the foot of the tree. The line crackled, and a rusty metal cage was lowered from above. House Mouse ushered Ivy in, and almost immediately the cage began rising.

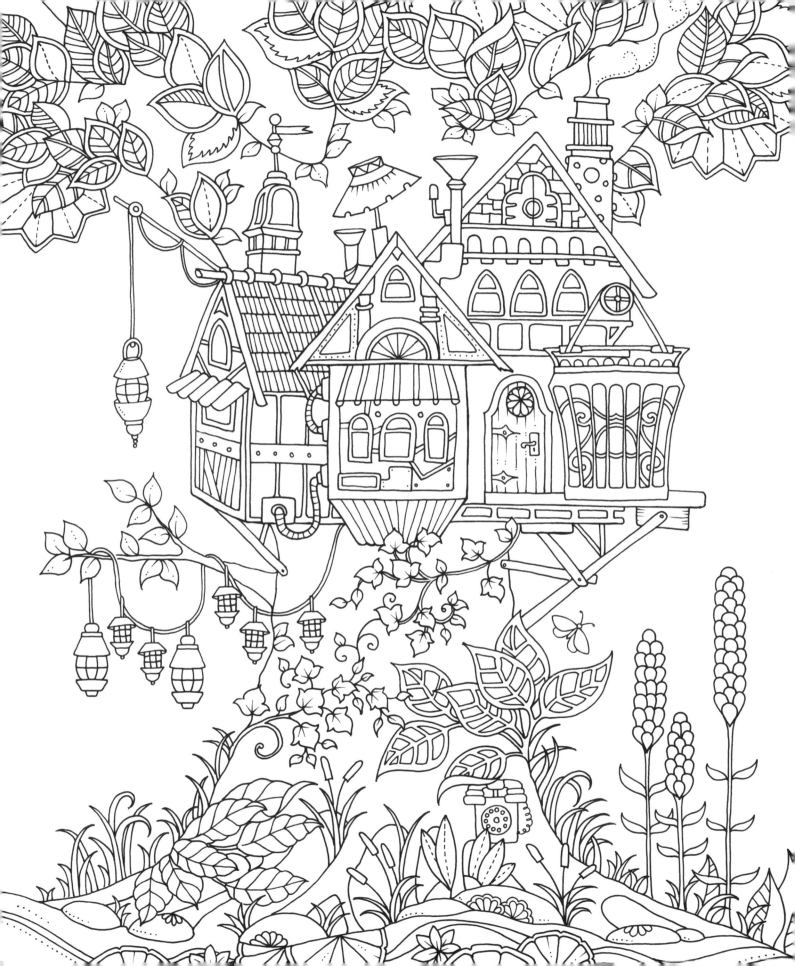

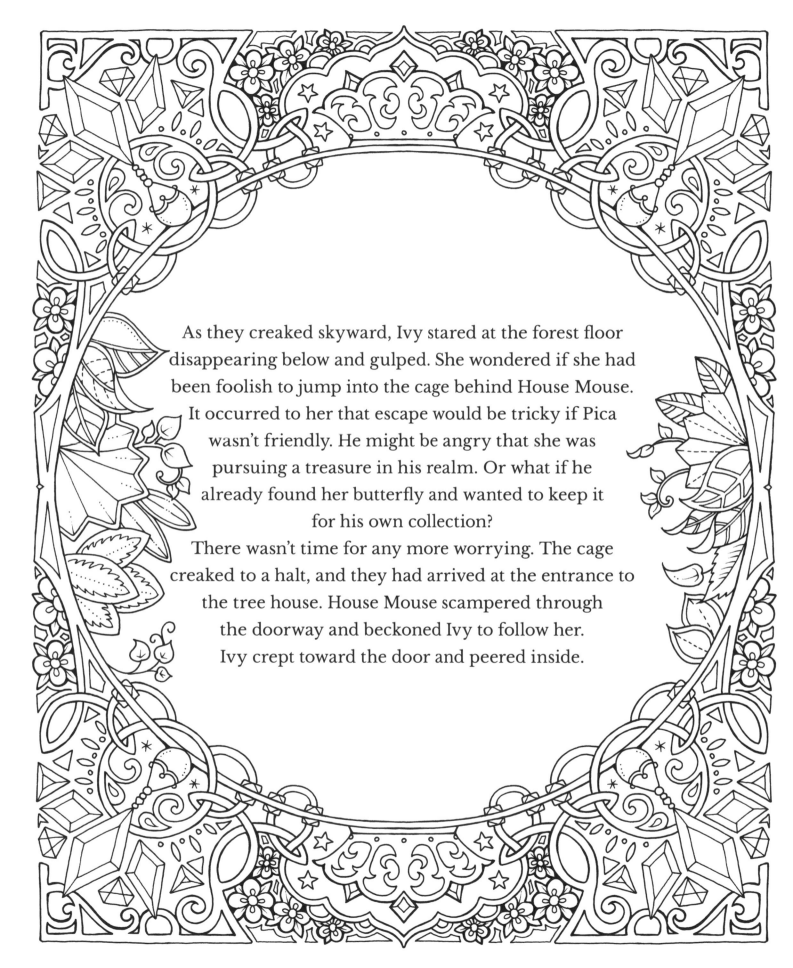

As they creaked skyward, Ivy stared at the forest floor
disappearing below and gulped. She wondered if she had
been foolish to jump into the cage behind House Mouse.
It occurred to her that escape would be tricky if Pica
wasn't friendly. He might be angry that she was
pursuing a treasure in his realm. Or what if he
already found her butterfly and wanted to keep it
for his own collection?

There wasn't time for any more worrying. The cage
creaked to a halt, and they had arrived at the entrance to
the tree house. House Mouse scampered through
the doorway and beckoned Ivy to follow her.
Ivy crept toward the door and peered inside.

It was exactly as House Mouse had described it. Every inch of the tree house was covered in shiny charms or trinkets. Polished cutlery hung from the leaky ceiling like wind chimes, and gold filigree broaches studded the walls like paintings. The shabby dressers were lined with golden goblets and silver serving platters.

Perched at a workbench, a pair of spectacles balanced on his beak and surrounded by scrubbing brushes and polishing cloths, was a black-and-white magpie. "Hello, you must be Ivy. House Mouse has told me all about you," he said warmly. Ivy smiled, relieved he seemed like a friendly fellow.

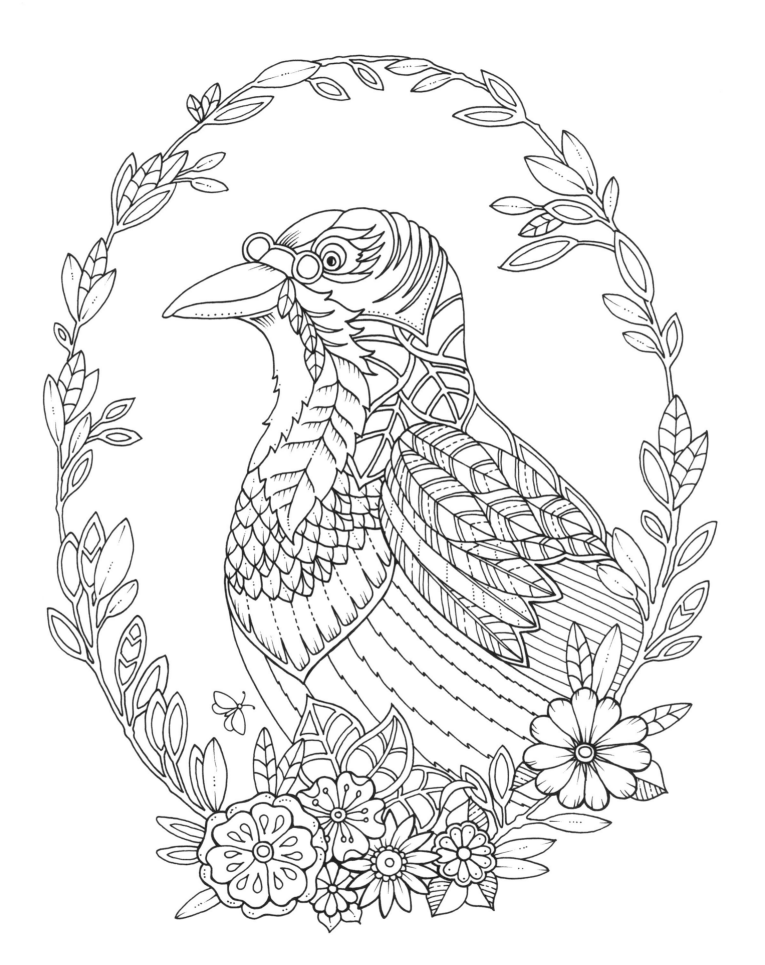

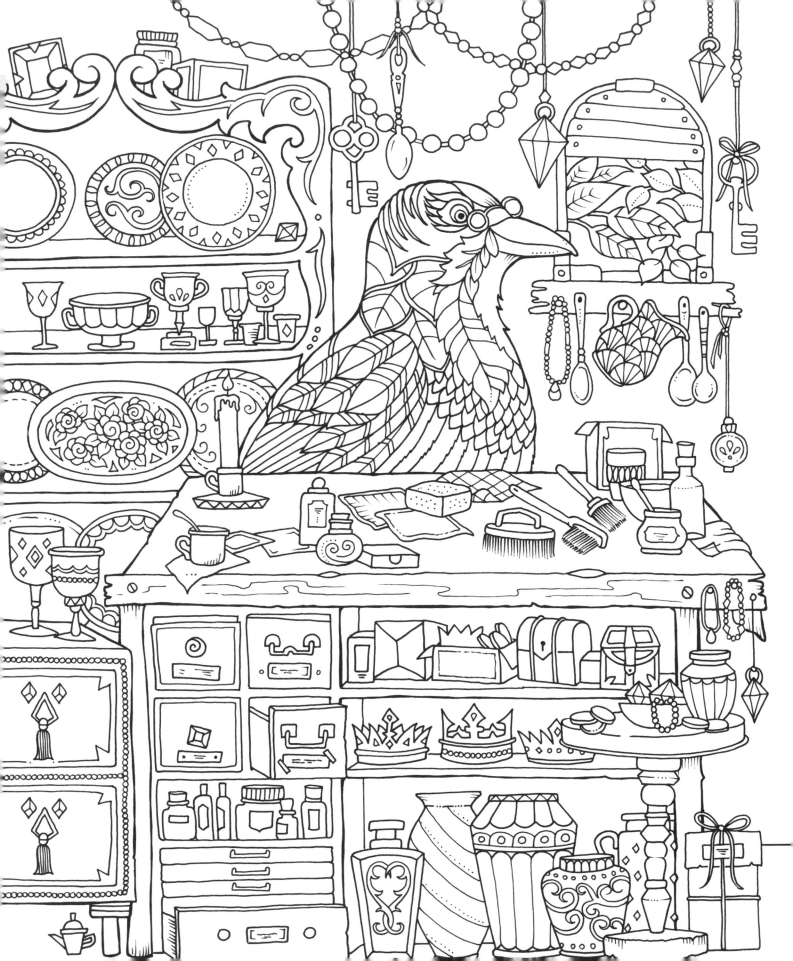

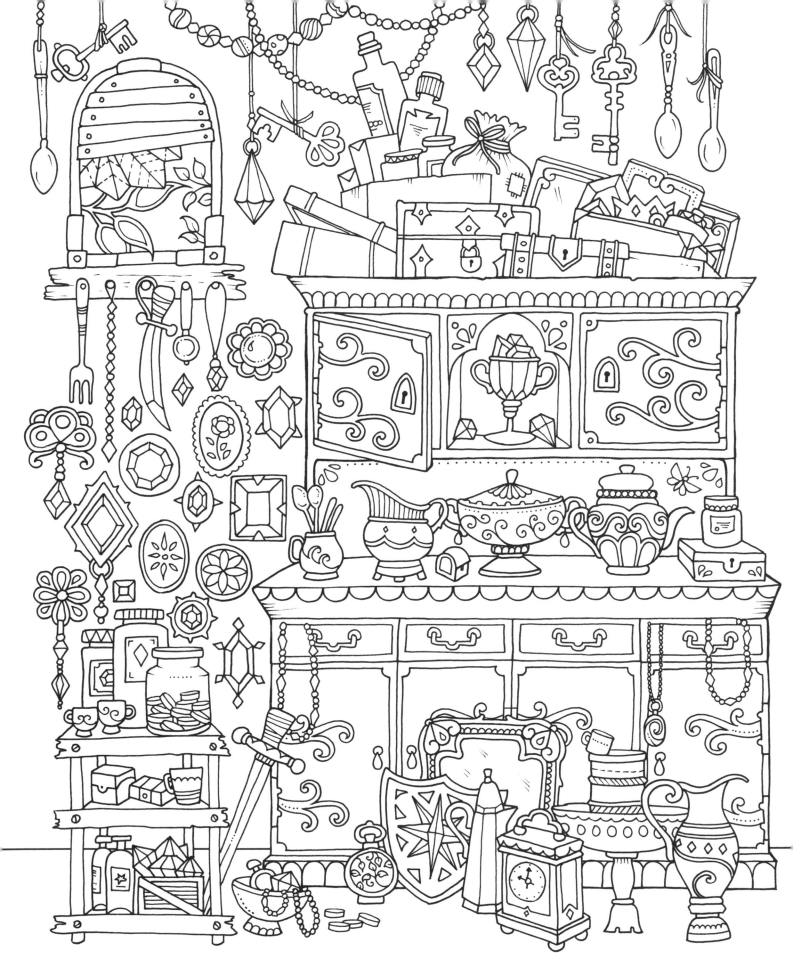

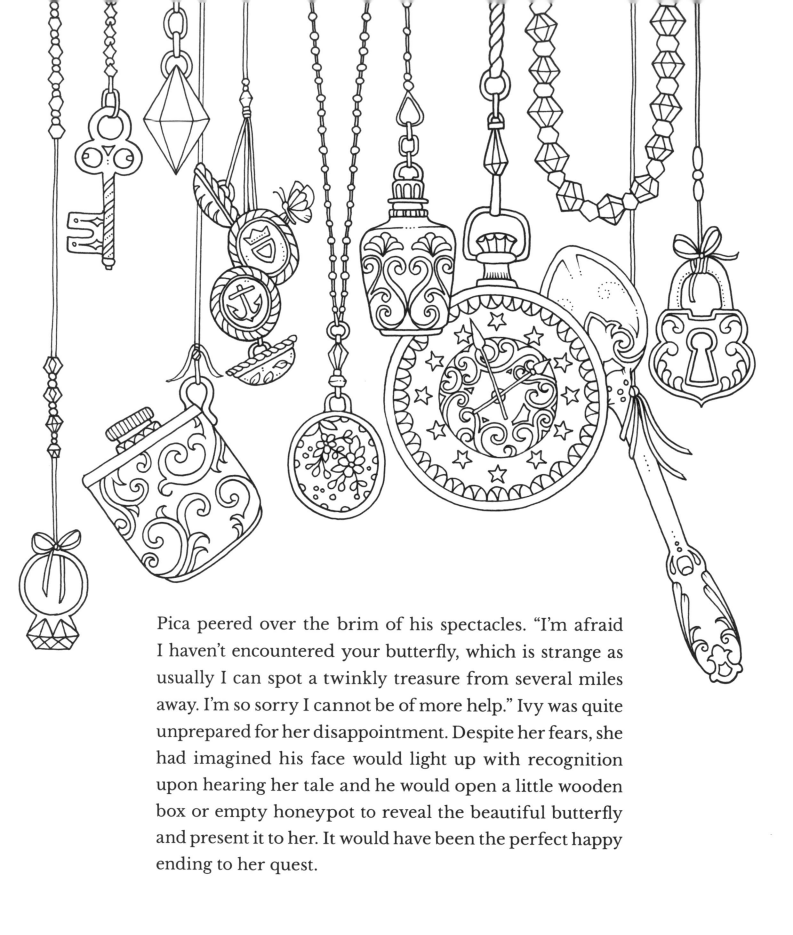

Pica peered over the brim of his spectacles. "I'm afraid I haven't encountered your butterfly, which is strange as usually I can spot a twinkly treasure from several miles away. I'm so sorry I cannot be of more help." Ivy was quite unprepared for her disappointment. Despite her fears, she had imagined his face would light up with recognition upon hearing her tale and he would open a little wooden box or empty honeypot to reveal the beautiful butterfly and present it to her. It would have been the perfect happy ending to her quest.

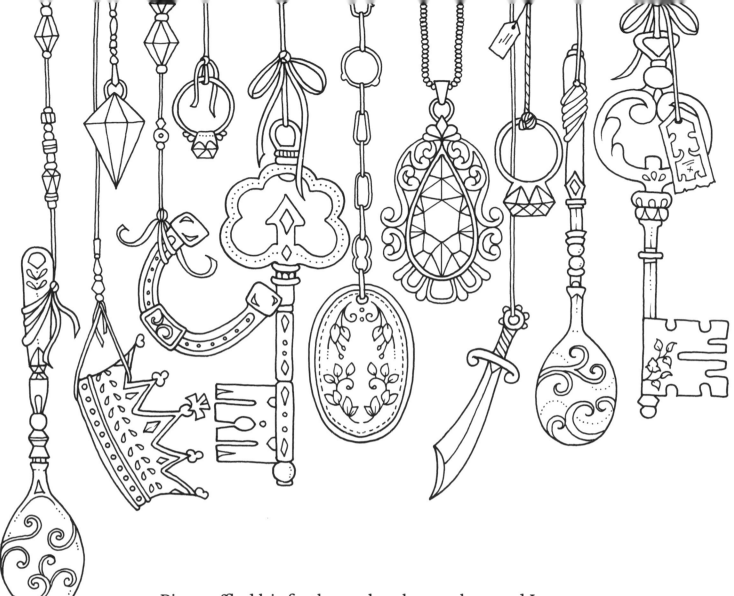

Pica ruffled his feathers when he saw how sad Ivy was. "Oh, dear me, this won't do at all," he cooed gently.

"It's all my fault," squeaked House Mouse. "If I hadn't cleaned away the ink, the trail wouldn't have been broken and Ivy could have found her butterfly." A tiny tear trickled down the mouse's nose. Despite being very upset herself, Ivy couldn't bear to see the mouse so sad, so she put her arm around her and gave her a hug.

Without a word, Pica jumped off his stool and began rummaging through drawers and cabinets, throwing treasures to one side as he searched for something.

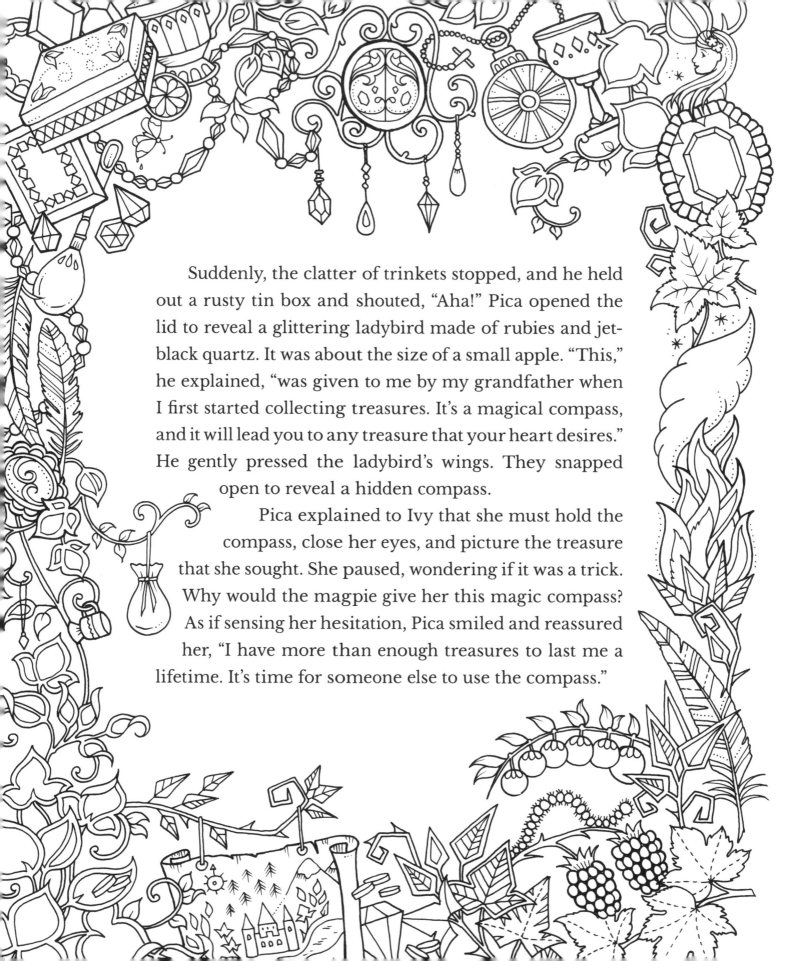

Suddenly, the clatter of trinkets stopped, and he held out a rusty tin box and shouted, "Aha!" Pica opened the lid to reveal a glittering ladybird made of rubies and jet-black quartz. It was about the size of a small apple. "This," he explained, "was given to me by my grandfather when I first started collecting treasures. It's a magical compass, and it will lead you to any treasure that your heart desires." He gently pressed the ladybird's wings. They snapped open to reveal a hidden compass.

Pica explained to Ivy that she must hold the compass, close her eyes, and picture the treasure that she sought. She paused, wondering if it was a trick. Why would the magpie give her this magic compass? As if sensing her hesitation, Pica smiled and reassured her, "I have more than enough treasures to last me a lifetime. It's time for someone else to use the compass."

Slowly, she reached out her hand and took the jeweled ladybird from him. She stood with the compass cupped in her hands, shut her eyes, and imagined the beautiful butterfly. When she looked down, the needle of the compass was spinning around wildly. Pica and House Mouse held their breath as the needle slowed to a wavering tick, finally settling on due south. "Dragonia!" House Mouse whispered, and looked at Pica with wide, scared eyes.

"What's Dragonia?" Ivy asked.

Pica pointed to a map of Enchantia, pinned to the tree-house wall. "South of the forest is a castle, surrounded by flaming thorns and inhabited by a fearsome family of dragons. Nobody has ventured there for many hundreds of years."

House Mouse and Pica watched Ivy, unsure of whether she would still want to continue, now that the journey would take her somewhere so dangerous.

But Ivy stood up straight and took a deep breath. "Well, it seems I'm off to visit some dragons," she declared boldly.

"Then I shall be at your side," said House Mouse, taking Ivy's hand in her own little paw and squeezing it gently. Ivy smiled.

Ivy and House Mouse waved good-bye to Pica, the magical compass safely tucked into Ivy's pocket, and began their long trek through the forest. They wandered through foxgloves and snowdrops, over moss-clad tree stumps and through woodland clearings.

Many hours passed, and Ivy's legs ached with tiredness. Daylight faded, and high above the treetops a starry night sky began to emerge. Ahead, Ivy could see a cluster of twinkling lights, as though a tiny galaxy had fallen from the sky.

"Aha, we're right on time!" said House Mouse, who suddenly had a spring in her step and scampered toward the illuminations. As she grew nearer, Ivy realized the lights were not fallen stars but garlands of lanterns strung between the trees above a circle of toadstools. The golden haze looked so warm and welcoming in the cold, dark forest.

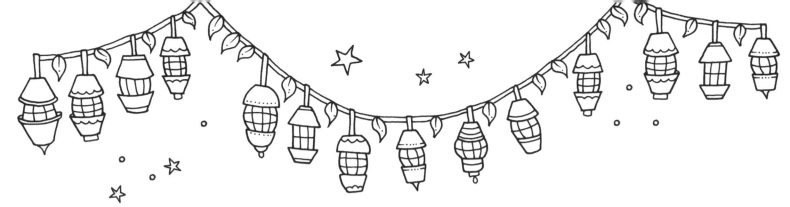

"This village is the home of the woodland elves," explained House Mouse cheerily. "We can rest here for a few hours. The elves pride themselves on being the best hosts in Enchantia, and we're just in time for the evening feast!"

Ivy did her best to mirror House Mouse's happy expression, but secretly she was worried. Surely the elves would want something in return for their hospitality? The only thing she had to repay them with was the compass, and she couldn't give that away.

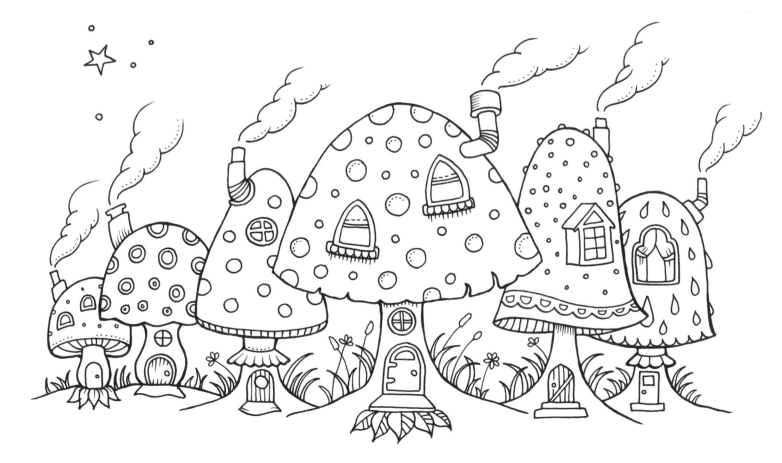

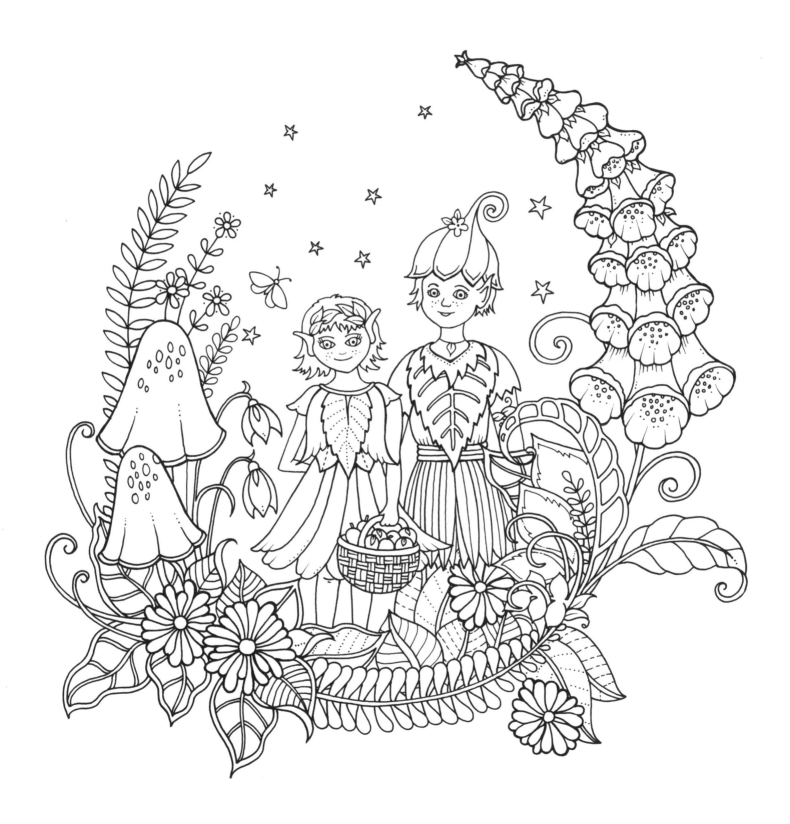

Laid out under the lanterns was a long wooden table piled high with apples, berries, nuts of every kind, freshly baked bread, pots of honey, and blackberry tarts. A huddle of elves, all dressed in leafy tunics and dresses, appeared from inside the toadstool houses. "Welcome! Welcome!" they shouted. "Please join us for a feast!"

As Ivy passed a plate of blackberry tarts to House Mouse and clinked goblets with her new friends, she realized for the first time how lovely it was to be part of the chatter and laughter that engulfs a dinner table.

The elves were an inquisitive bunch and wanted to know all about Ivy and her companion. Where had they come from? Where were they going? What were they seeking? They listened, falling quiet and wide-eyed when Ivy revealed that they were headed to Dragonia.

"You must eat plenty to fuel you for this quest," insisted plump old Grandmother Elf. So Ivy and House Mouse ate every single bite on their plates and then had second helpings. The food was the most delicious Ivy had ever tasted. As she sunk her teeth into an apple muffin, the familiar scent of freshly baked cake filled her nose, and for a brief moment she was reminded of her grandmother, busy in the kitchen of the little pink house. For the first time on her adventure, she felt far, far away from home.

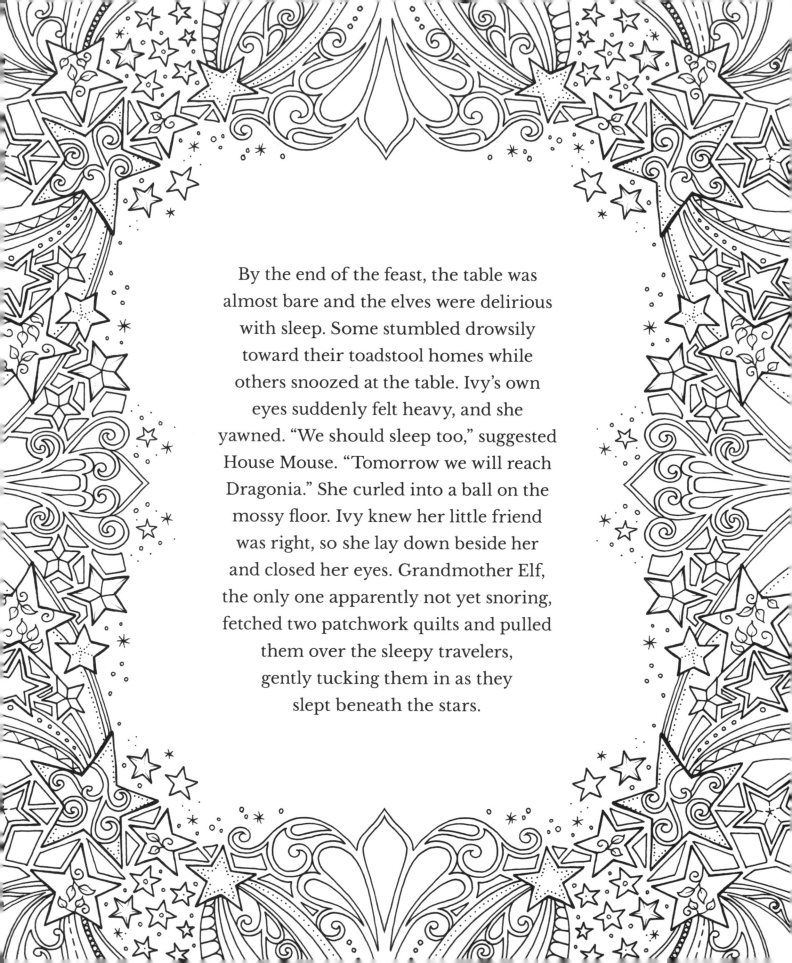

By the end of the feast, the table was
almost bare and the elves were delirious
with sleep. Some stumbled drowsily
toward their toadstool homes while
others snoozed at the table. Ivy's own
eyes suddenly felt heavy, and she
yawned. "We should sleep too," suggested
House Mouse. "Tomorrow we will reach
Dragonia." She curled into a ball on the
mossy floor. Ivy knew her little friend
was right, so she lay down beside her
and closed her eyes. Grandmother Elf,
the only one apparently not yet snoring,
fetched two patchwork quilts and pulled
them over the sleepy travelers,
gently tucking them in as they
slept beneath the stars.

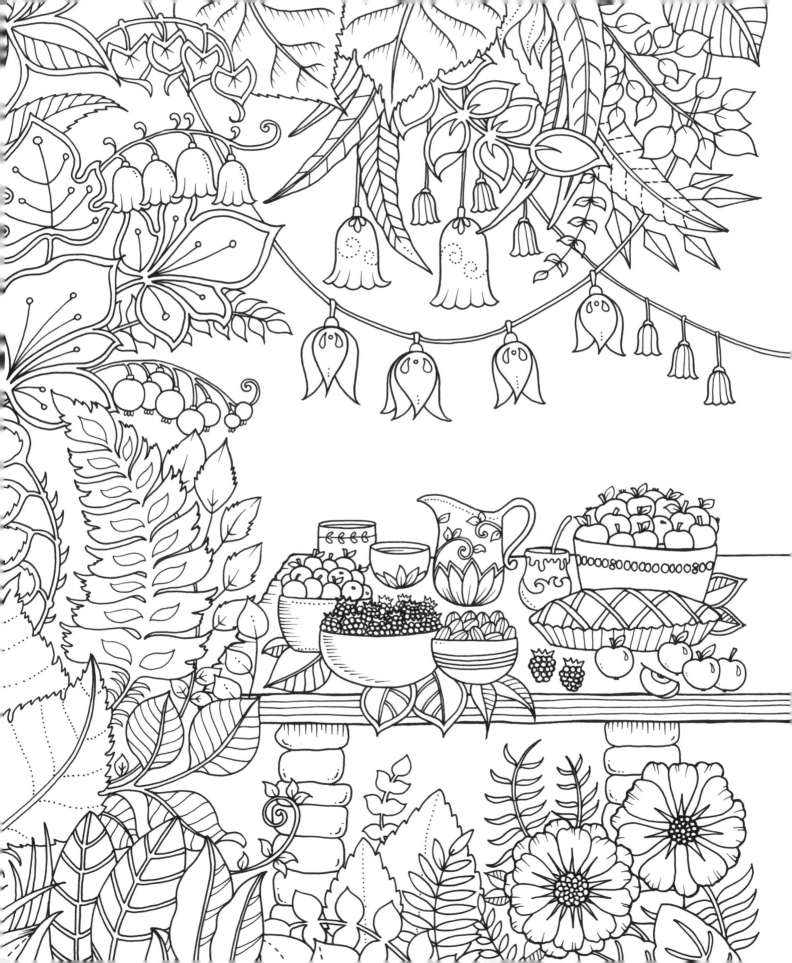

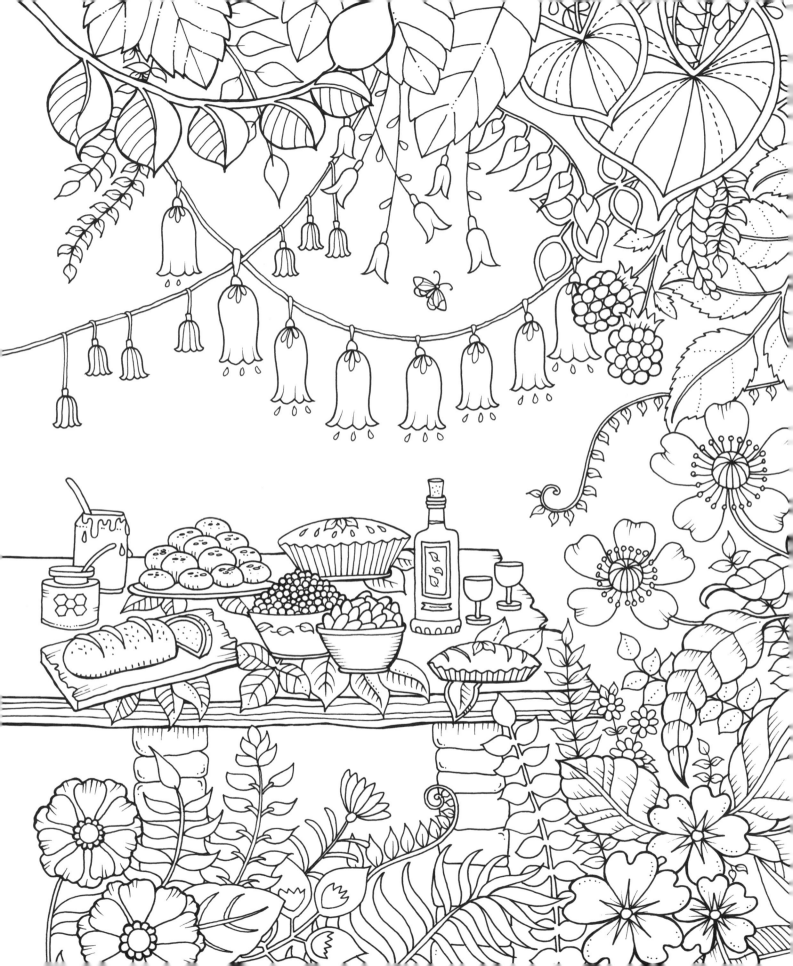

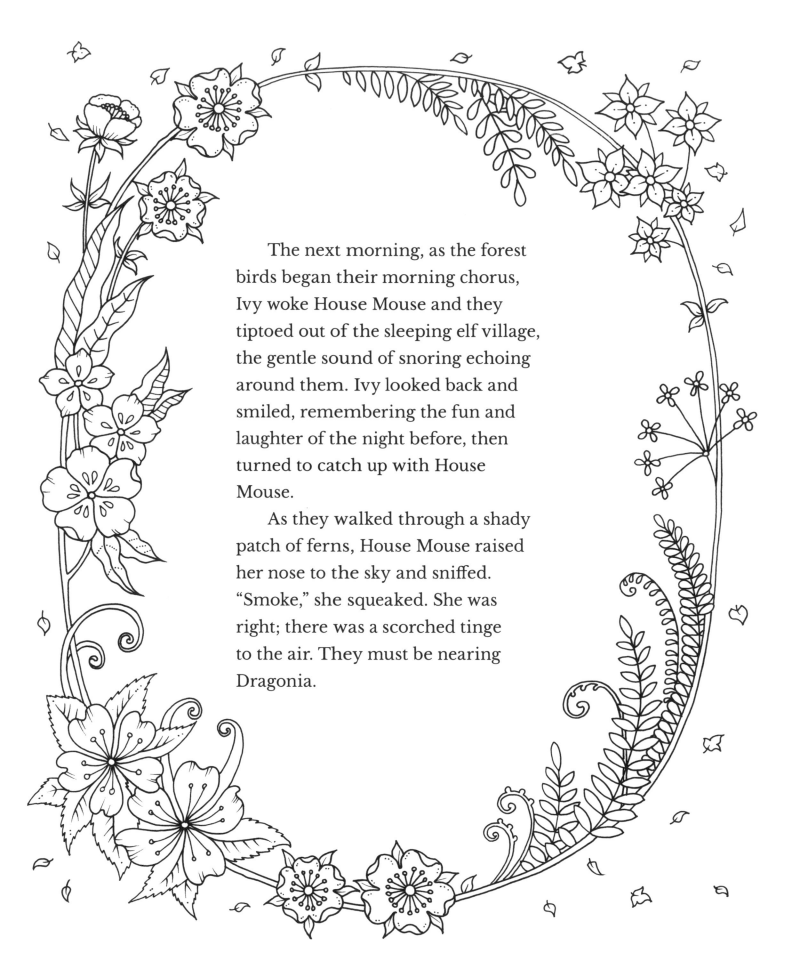

The next morning, as the forest birds began their morning chorus, Ivy woke House Mouse and they tiptoed out of the sleeping elf village, the gentle sound of snoring echoing around them. Ivy looked back and smiled, remembering the fun and laughter of the night before, then turned to catch up with House Mouse.

As they walked through a shady patch of ferns, House Mouse raised her nose to the sky and sniffed. "Smoke," she squeaked. She was right; there was a scorched tinge to the air. They must be nearing Dragonia.

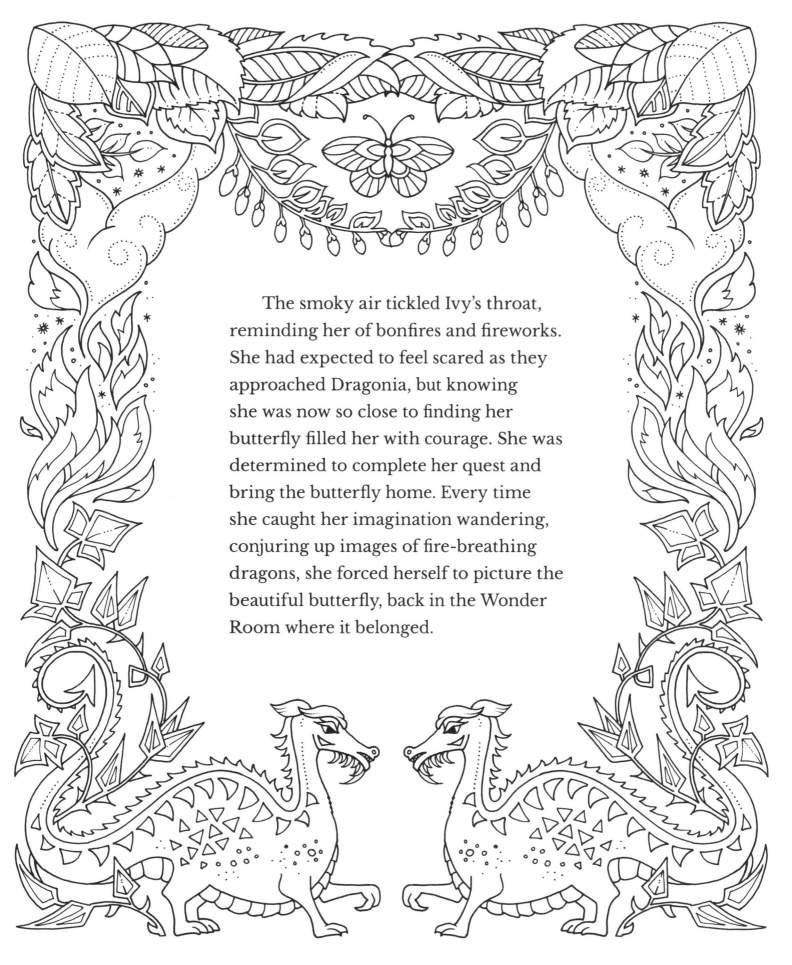

The smoky air tickled Ivy's throat, reminding her of bonfires and fireworks. She had expected to feel scared as they approached Dragonia, but knowing she was now so close to finding her butterfly filled her with courage. She was determined to complete her quest and bring the butterfly home. Every time she caught her imagination wandering, conjuring up images of fire-breathing dragons, she forced herself to picture the beautiful butterfly, back in the Wonder Room where it belonged.

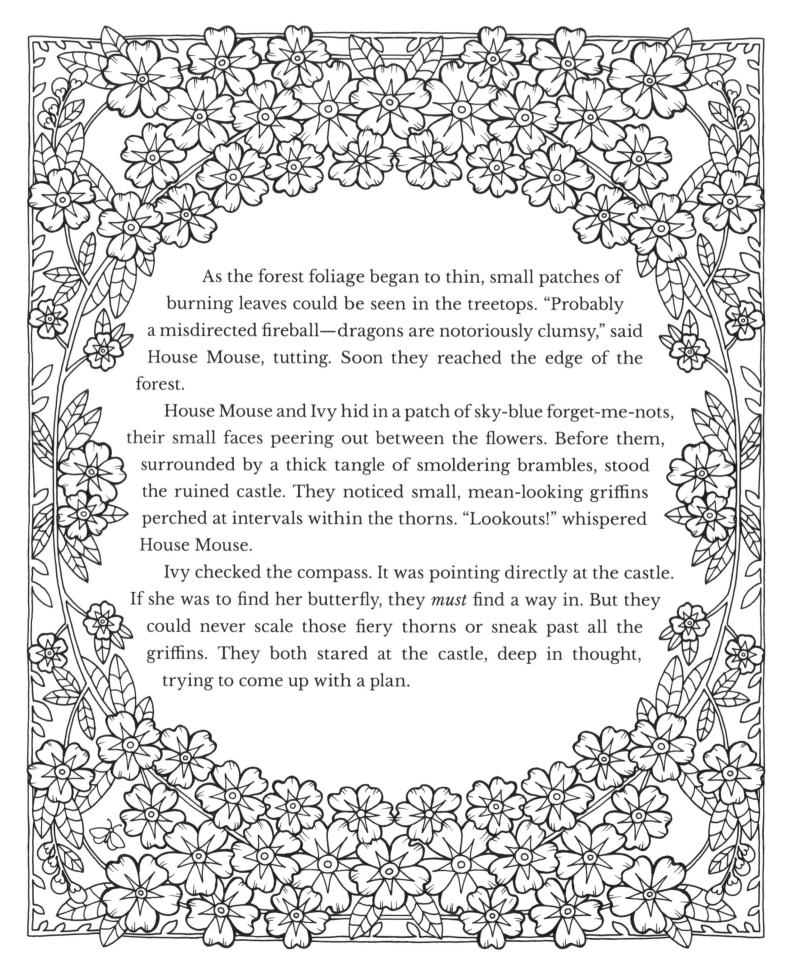

As the forest foliage began to thin, small patches of burning leaves could be seen in the treetops. "Probably a misdirected fireball—dragons are notoriously clumsy," said House Mouse, tutting. Soon they reached the edge of the forest.

House Mouse and Ivy hid in a patch of sky-blue forget-me-nots, their small faces peering out between the flowers. Before them, surrounded by a thick tangle of smoldering brambles, stood the ruined castle. They noticed small, mean-looking griffins perched at intervals within the thorns. "Lookouts!" whispered House Mouse.

Ivy checked the compass. It was pointing directly at the castle. If she was to find her butterfly, they *must* find a way in. But they could never scale those fiery thorns or sneak past all the griffins. They both stared at the castle, deep in thought, trying to come up with a plan.

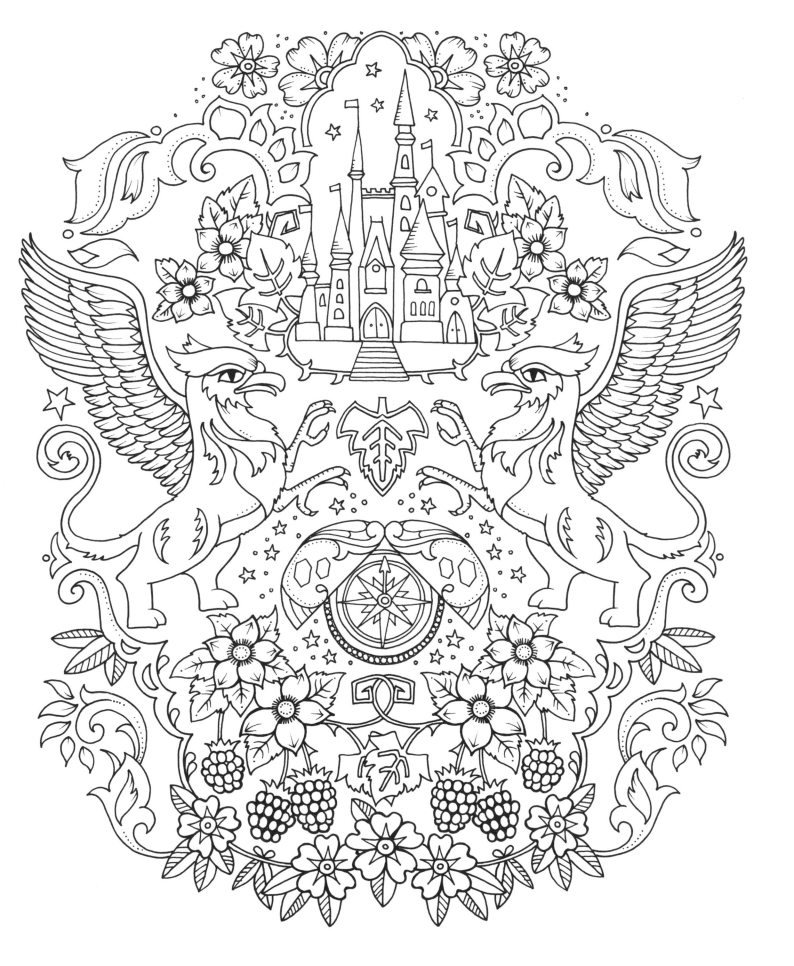

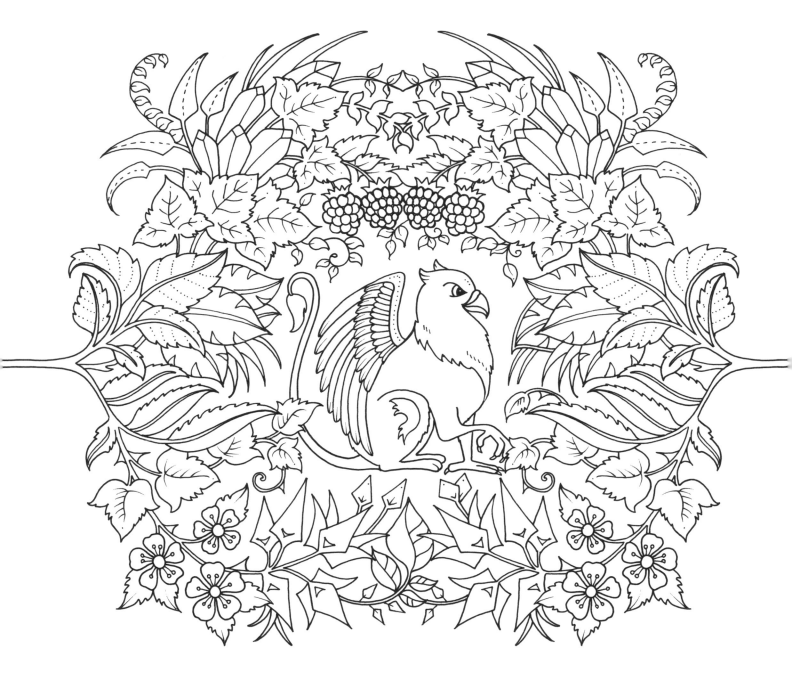

Noticing a small gap in the brambles directly beneath a bored-looking griffin, Ivy pointed to it. "Look, House Mouse!" she said. "I'm sure we could crawl through that hole." House Mouse peered through the smoke to where Ivy was pointing. She nodded.

Before they had time to consider the dangers, Ivy and House Mouse crept from the safety of the forget-me-nots and scampered along the thorn-lined path toward the castle, being careful to avoid the glowing embers and hot spots. They ducked beneath smoldering leaves and hid in the shadows, hoping the griffins wouldn't look directly down. They were almost at the gap when a blast of air from above fanned the embers around them so they glowed red-hot. They heard a terrifying screech and the flap of wings. Suddenly, Ivy and House Mouse were snatched from the ground by scaly talons and carried off into the sky by a furious griffin.

Ivy looked below them, but her view was obscured by thick clouds of smoke. The griffin continued to let out an earsplitting screech, possibly in triumph at its find or to warn the dragons of the trespassers. "Ivy! What shall we do?" squeaked House Mouse, her voice shaking with fear. "I really don't know!" replied Ivy, tears welling in her eyes. She realized how silly it was of her to think a small girl and a mouse could outfox a griffin. Just as she was regretting ever finding the door in the Wonder Room, she heard a familiar buzzing noise. "Can you hear that?" she called to House Mouse, the wind whistling in their ears and the noise of the griffin's wings beating loudly. "Yes!" shouted House Mouse, listening intently. "What is it?"

Ivy and House Mouse listened as the buzzing grew louder and stronger. Suddenly, out of the smoke, her bee appeared! He charged toward the griffin, but the fierce beast flicked at the bee with its wing, sending it hurtling through the air in a blur of yellow and black. The bee buzzed in small circles, stunned by the collision. "What could one little bee possibly do when faced by a griffin?" thought Ivy desperately.

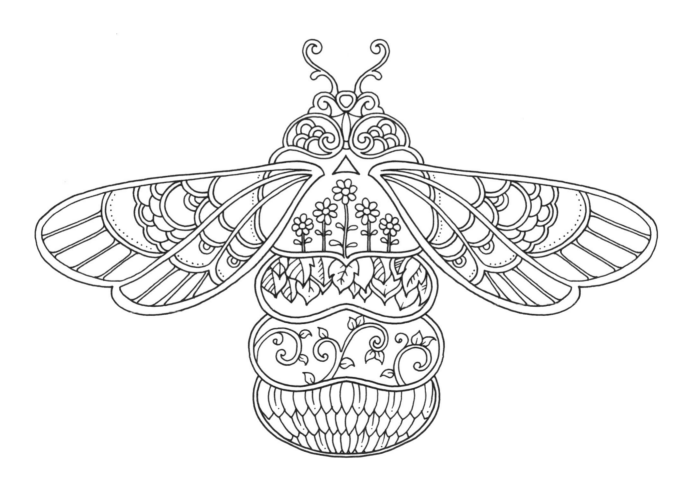

She noticed the noise altered in tone and volume to a deep, loud humming, like the sound of one hundred motorbikes getting closer. The griffin heard it too. Ivy saw it jerk its head left and right, straining to see where the noise was coming from.

Out of the dense smoke, a swarm of bees arrived, charging at the griffin! Leading the attack was the Queen Bee, a tiny golden crown perched upon her head. The bees approached as a throbbing cloud of black, surrounding the griffin and engulfing it in a thunderous storm of buzzing. The griffin lurched through the air, disoriented and confused; then, without warning, it released Ivy and House Mouse from its talons.

They hurtled toward the flaming thorns below, somersaulting through the air. Two bees broke off from the pack and sped toward Ivy and House Mouse, scooping them onto their fluffy backs and saving them from the perilous fate.

Ivy collapsed onto the back of the bee and clung on. She saw House Mouse doing the same, her little body still trembling. The swarm retreated to the forest and settled in a small clearing at the foot of a giant oak tree. As Ivy and House Mouse slid from their bees and caught their breath, the bees surrounded them, their buzzing quieting to a low hum.

The Queen Bee landed in front of Ivy and House Mouse. "That was a rather daring feat," she said, and around her the others hummed in agreement. "I know, it seems silly now to think we could have snuck past the griffins," replied Ivy, her voice quiet in defeat.

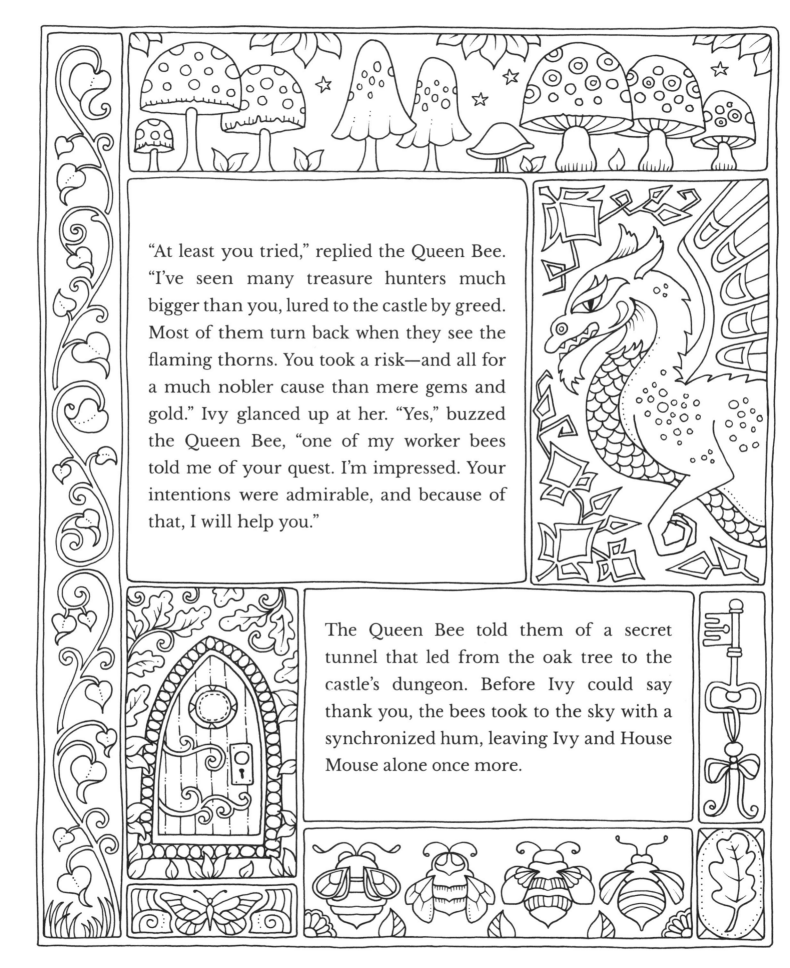

"At least you tried," replied the Queen Bee. "I've seen many treasure hunters much bigger than you, lured to the castle by greed. Most of them turn back when they see the flaming thorns. You took a risk—and all for a much nobler cause than mere gems and gold." Ivy glanced up at her. "Yes," buzzed the Queen Bee, "one of my worker bees told me of your quest. I'm impressed. Your intentions were admirable, and because of that, I will help you."

The Queen Bee told them of a secret tunnel that led from the oak tree to the castle's dungeon. Before Ivy could say thank you, the bees took to the sky with a synchronized hum, leaving Ivy and House Mouse alone once more.

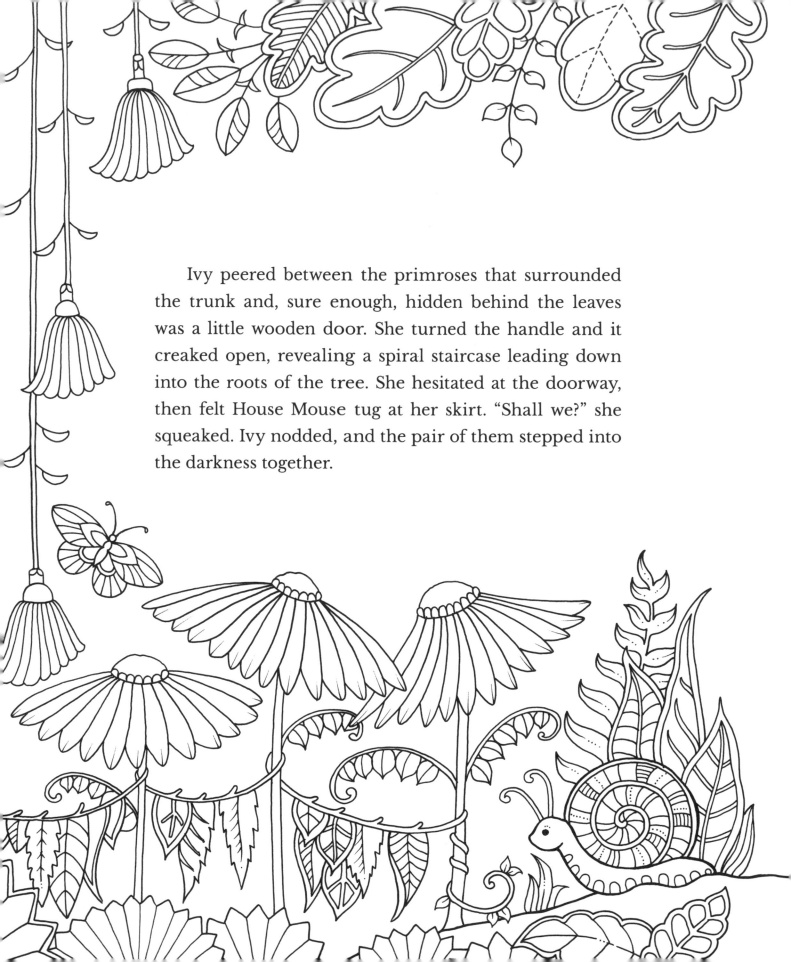

Ivy peered between the primroses that surrounded the trunk and, sure enough, hidden behind the leaves was a little wooden door. She turned the handle and it creaked open, revealing a spiral staircase leading down into the roots of the tree. She hesitated at the doorway, then felt House Mouse tug at her skirt. "Shall we?" she squeaked. Ivy nodded, and the pair of them stepped into the darkness together.

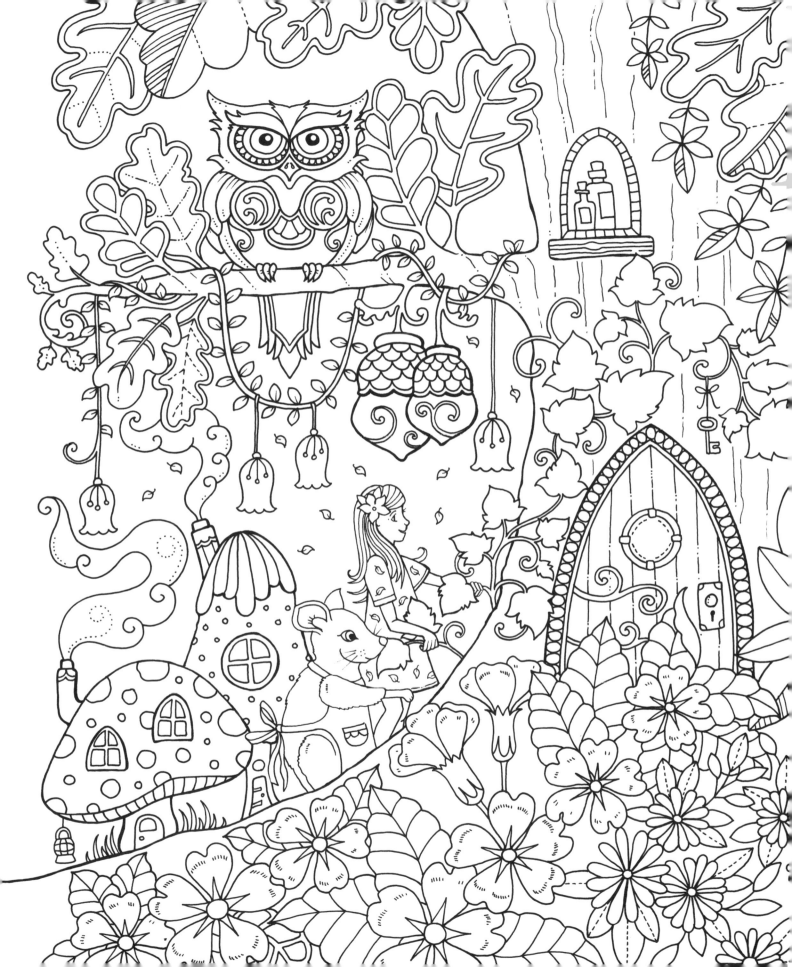

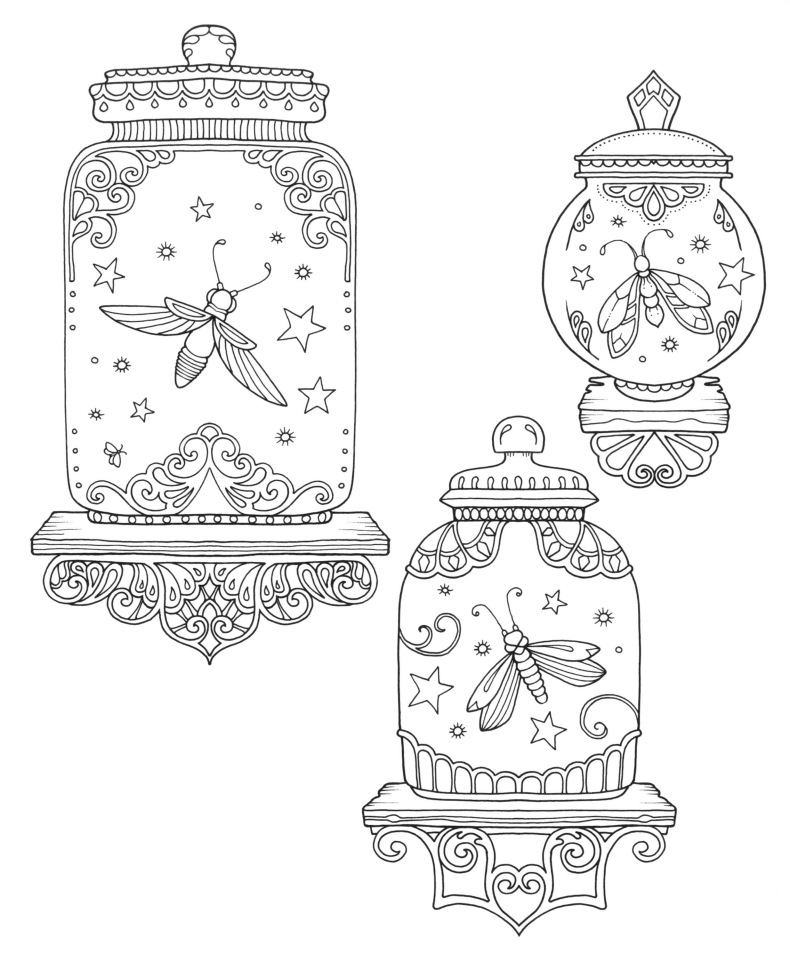

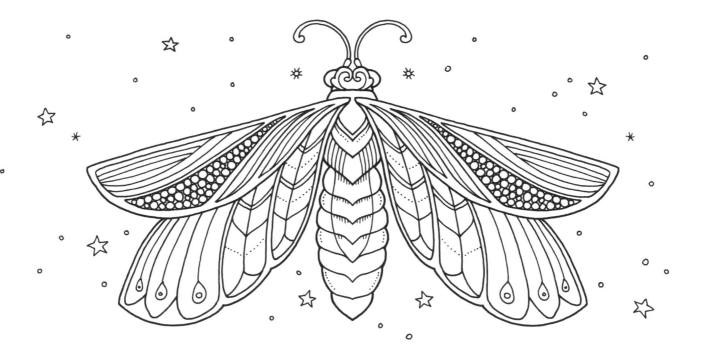

It was as black as midnight in the tunnel, but as Ivy and House Mouse walked, hibernating fireflies snoozing in glass jars suddenly buzzed to life, illuminating the path with their warm glow. The tunnel was laced with dusty cobwebs. "Oh my!" gasped House Mouse. "This place could do with a bit of a spring-cleaning."

Ivy chuckled at her little friend. She was grateful both for the light in the underground passageways and for having House Mouse at her side—the dark could be a scary place for someone with a big imagination, but having House Mouse with her gave her courage.

Soon, they saw a patch of light in the floor—a gap in the stonework. They peeked through the hole and saw a diamond chandelier suspended below them on the end of an enormous metal chain. Silently, they squeezed through the gap, climbed down the chain to the chandelier, and peered into the dungeon.

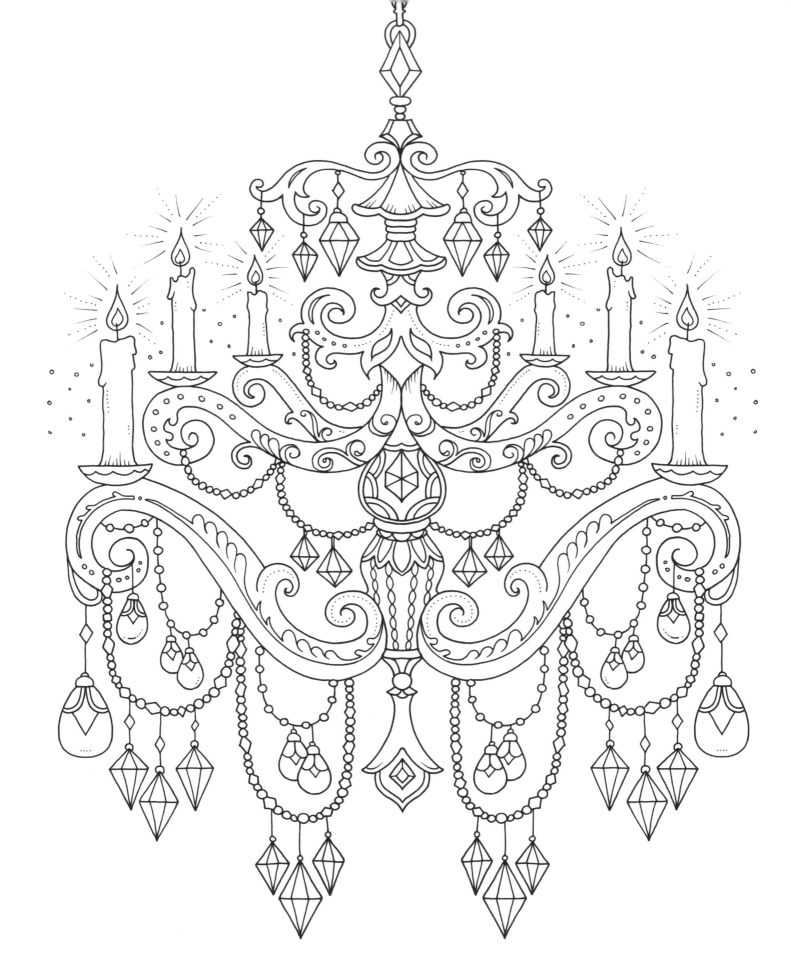

Beneath them a family of dragons, each armed with a sword, was gathered around a long banquet table, their teeth and talons glinting in the candlelight. Around the dragons, gemstones were clustered together in piles, stacked high in dazzling mountains, and chests and gold bowls overflowed with twinkling treasures. The dungeon walls were crumbling and stained black with smoke. Royal flags hung limply while suits of armor, knights' shields, and family portraits lay abandoned and broken.

Ivy and House Mouse watched silently as the dragons skewered chunks of meat from large platters, inhaled deeply, then unleashed balls of roaring fire and crackling flames onto the flesh, instantly roasting them. With theatrical flair, they tore the meat from the blade with their razorlike teeth while plumes of twisted black smoke escaped from their nostrils.

House Mouse gasped. "What have we done? We should never have come here!" she squeaked, her voice trembling.

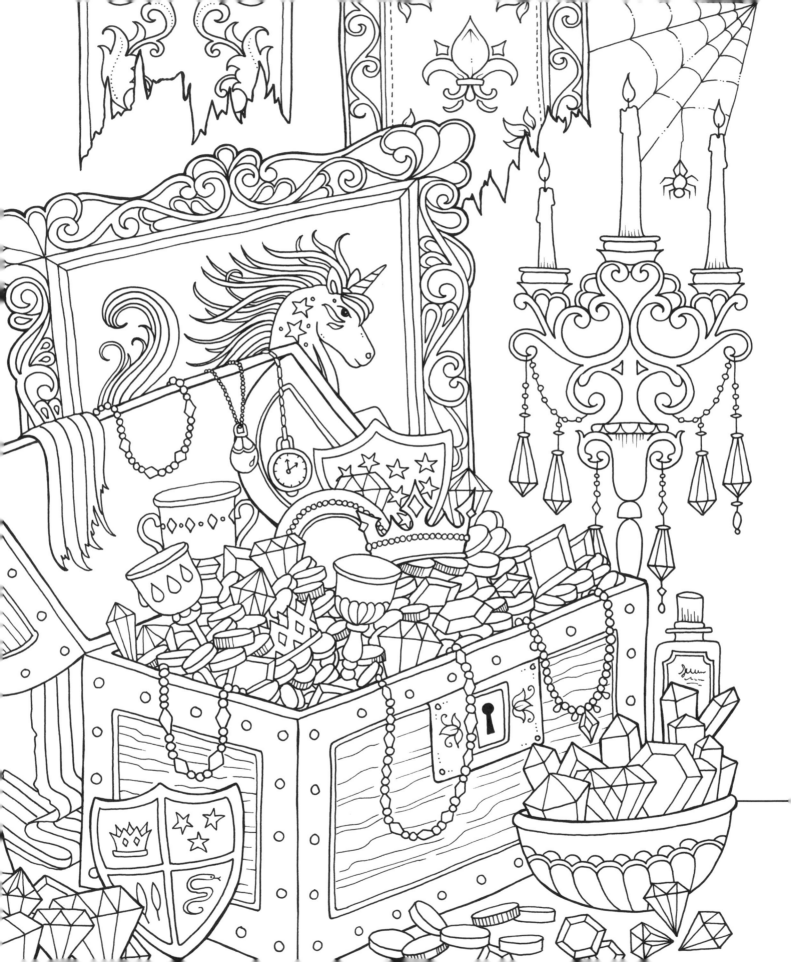

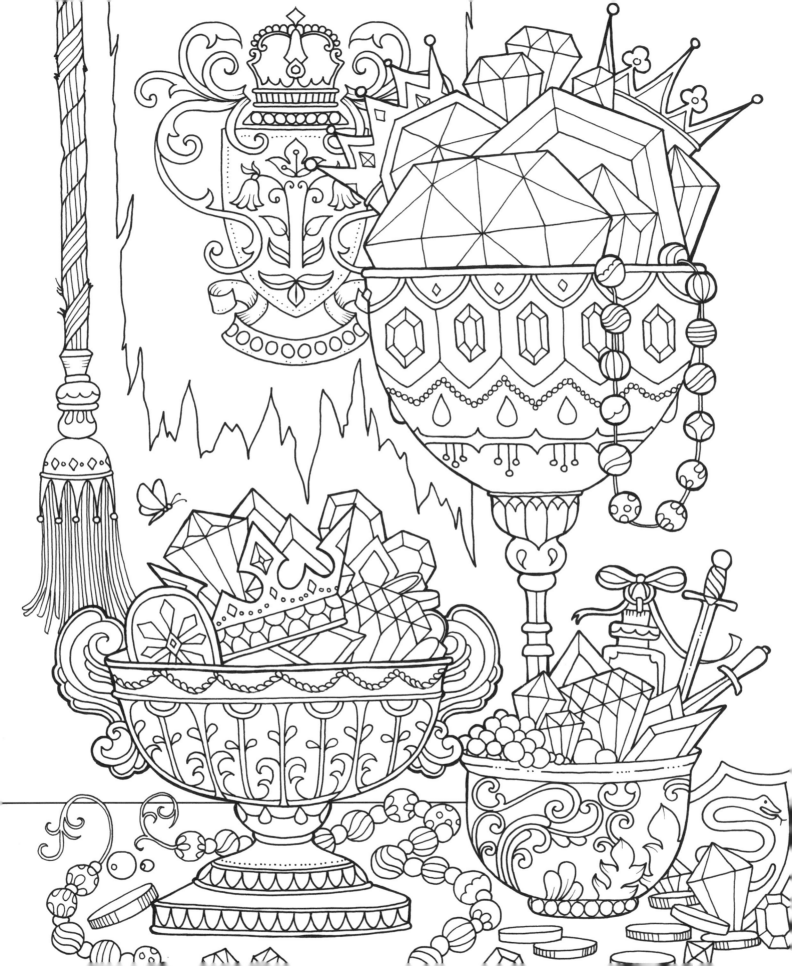

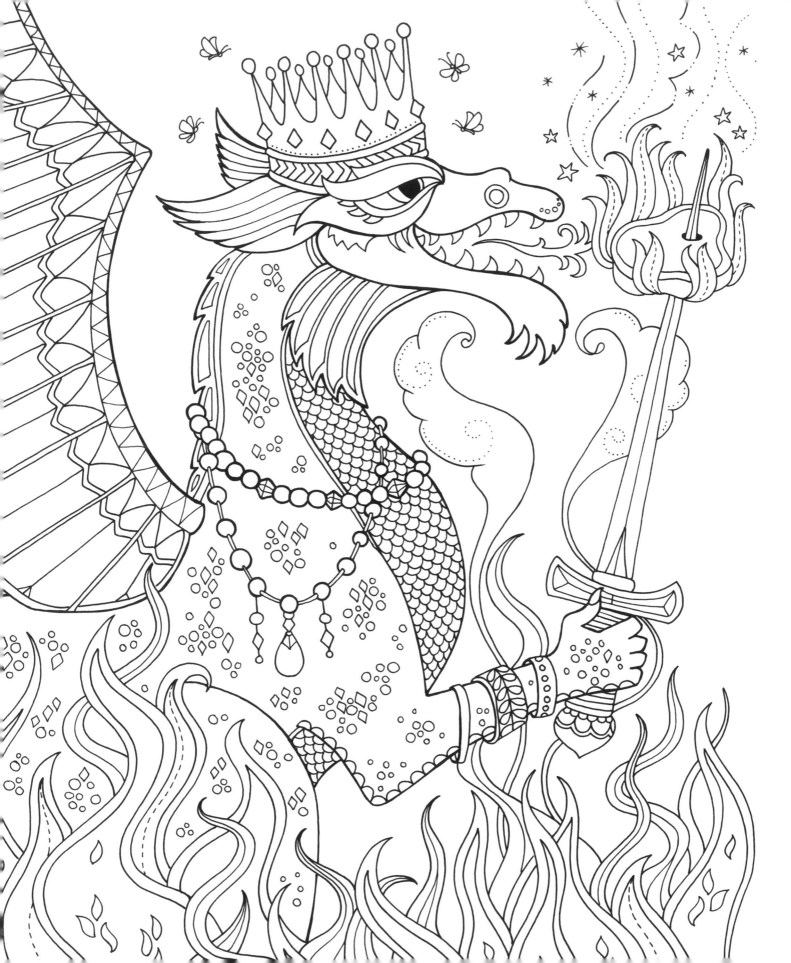

At the head of the scorched table sat the largest of the dragons. She was lounging on a shabby throne, a golden crown perched on her head. With long, sharp claws she plucked a piece of meat from the table, tossed it into the air above her, tipped back her head, and shot a blast of flames into the air. The charred chunk tumbled, still flaming, into her mouth where she swallowed it whole to rapturous cheers from the other dragons.

Ivy's hands trembled as she took the compass from her pocket and stared at it. The needle was pointing directly at the dragon on the throne. As Ivy stared at her, she noticed something small and black fluttering around the crown. It was difficult to see because of all the smoke, so she leaned forward, straining to see through the haze.

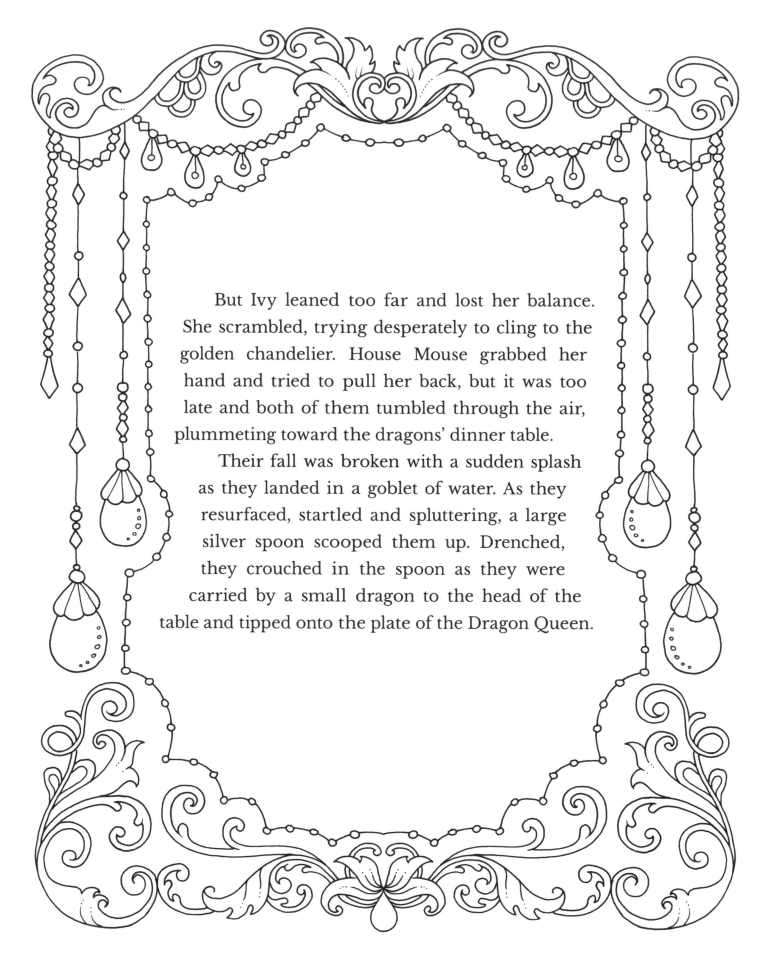

But Ivy leaned too far and lost her balance. She scrambled, trying desperately to cling to the golden chandelier. House Mouse grabbed her hand and tried to pull her back, but it was too late and both of them tumbled through the air, plummeting toward the dragons' dinner table.

Their fall was broken with a sudden splash as they landed in a goblet of water. As they resurfaced, startled and spluttering, a large silver spoon scooped them up. Drenched, they crouched in the spoon as they were carried by a small dragon to the head of the table and tipped onto the plate of the Dragon Queen.

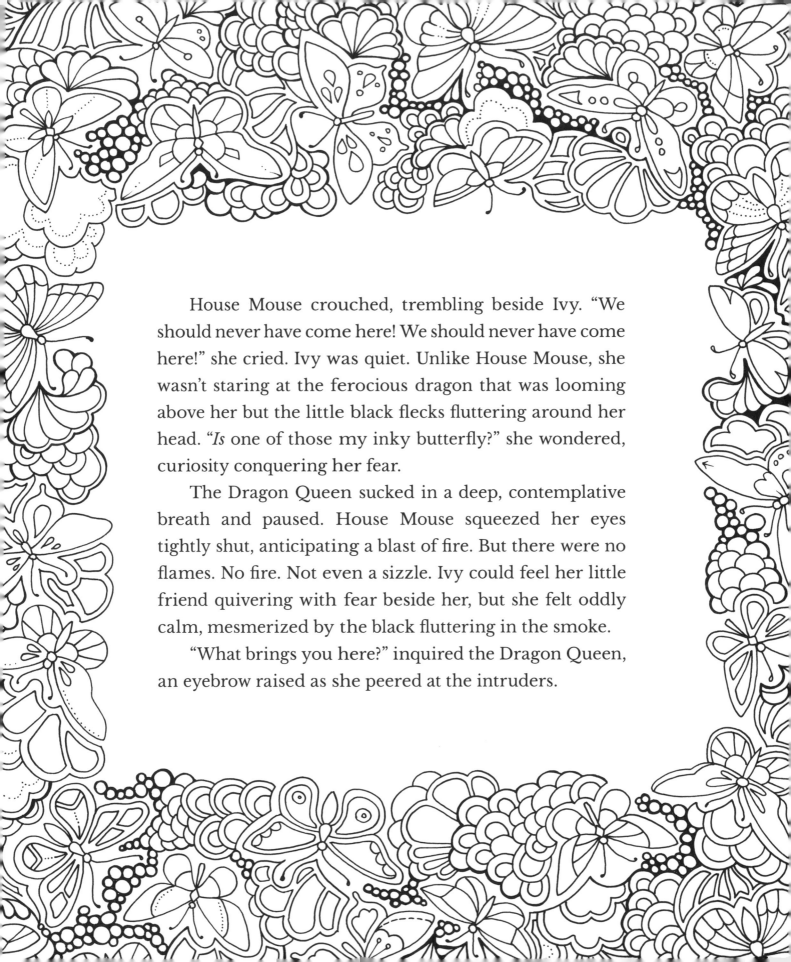

House Mouse crouched, trembling beside Ivy. "We should never have come here! We should never have come here!" she cried. Ivy was quiet. Unlike House Mouse, she wasn't staring at the ferocious dragon that was looming above her but the little black flecks fluttering around her head. "*Is* one of those my inky butterfly?" she wondered, curiosity conquering her fear.

The Dragon Queen sucked in a deep, contemplative breath and paused. House Mouse squeezed her eyes tightly shut, anticipating a blast of fire. But there were no flames. No fire. Not even a sizzle. Ivy could feel her little friend quivering with fear beside her, but she felt oddly calm, mesmerized by the black fluttering in the smoke.

"What brings you here?" inquired the Dragon Queen, an eyebrow raised as she peered at the intruders.

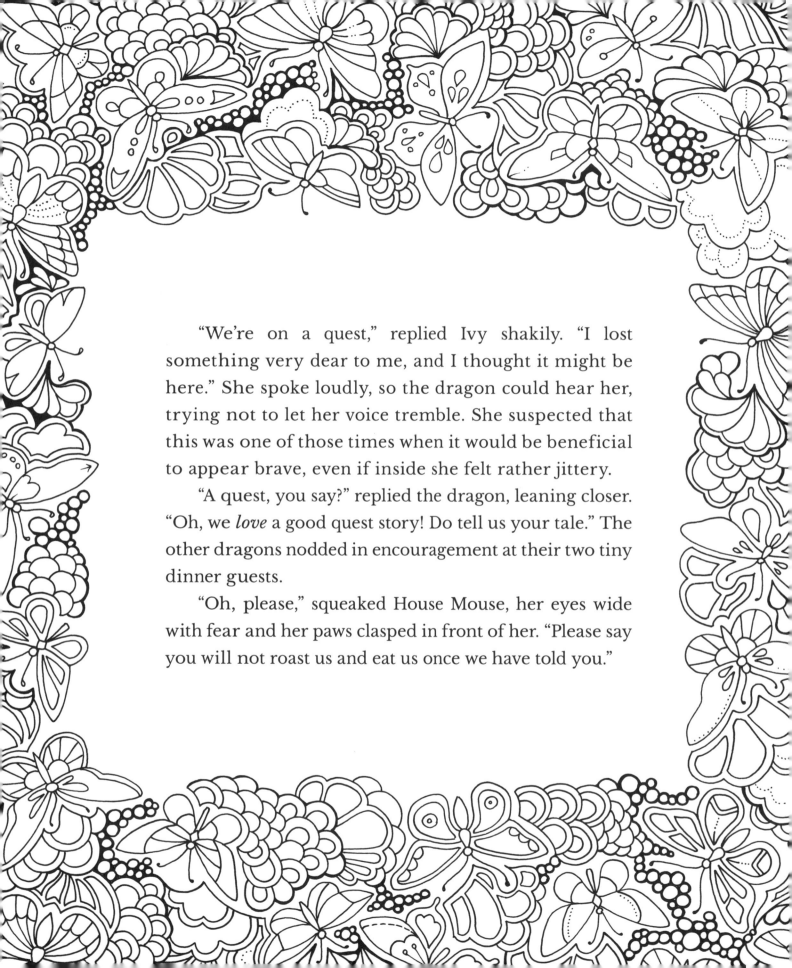

"We're on a quest," replied Ivy shakily. "I lost something very dear to me, and I thought it might be here." She spoke loudly, so the dragon could hear her, trying not to let her voice tremble. She suspected that this was one of those times when it would be beneficial to appear brave, even if inside she felt rather jittery.

"A quest, you say?" replied the dragon, leaning closer. "Oh, we *love* a good quest story! Do tell us your tale." The other dragons nodded in encouragement at their two tiny dinner guests.

"Oh, please," squeaked House Mouse, her eyes wide with fear and her paws clasped in front of her. "Please say you will not roast us and eat us once we have told you."

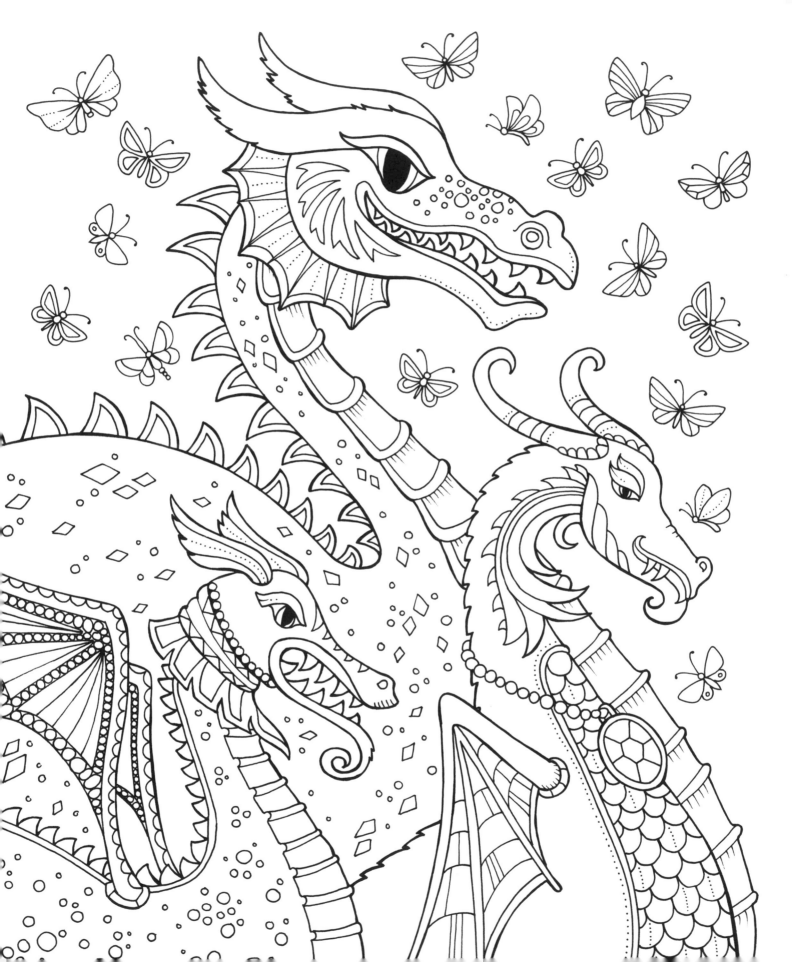

The dragons collectively let out a loud cackle of laughter that echoed off the dungeon walls. The Dragon Queen chuckled so much that she choked and a sharp spark of fire erupted from her left nostril. She composed herself. "Dear mouse, you have nothing to fear. You and your fellow adventurer would barely constitute a midmorning snack! Rest assured, we prefer to dine upon mystical beasts of decidedly bigger proportions."

No longer fearful that they were destined to become dessert, Ivy and House Mouse began to tell their story. They missed no detail, sensing the dragons' delight in a story well told. They explained all the incredible things they had seen traveling through Enchantia, the characters they had encountered, their midnight feast with the elves, and their close encounter with the griffins.

As their tale came to a close, the hushed audience turned to face the Dragon Queen. She glanced up and pointed at the black fluttering objects around her crown. "These?" she asked. "You think one of *these* is your butterfly? But they are just black moths."

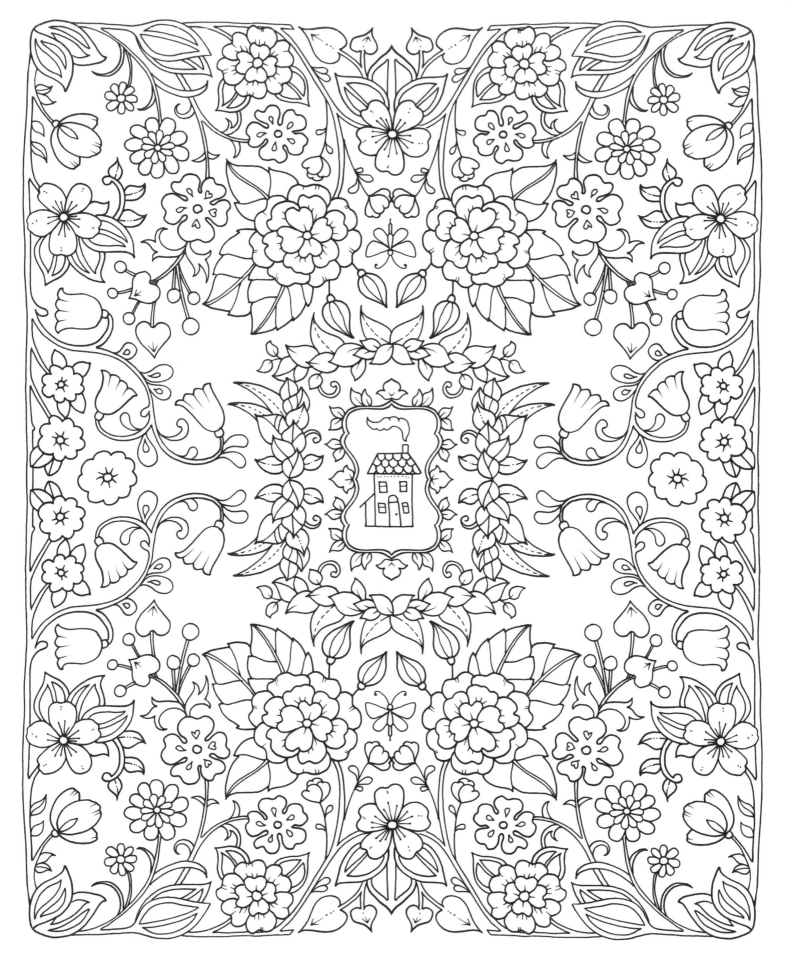

As the Dragon Queen spoke, a pair of black wings fluttered toward Ivy and landed delicately on her index finger. She examined its dull, black wings flecked in charcoal gray. There was not a single shimmer of gold, no hint of color or smudge of ink to be seen. Everyone fell silent.

"This isn't my butterfly," Ivy whispered. "It's just a black moth."

A single tear rolled down her cheek and fell onto the moth. Their journey had been for nothing. She suddenly felt incredibly homesick, longing to be back in her little pink house. She wondered why she'd been so foolish to chase the inky butterfly.

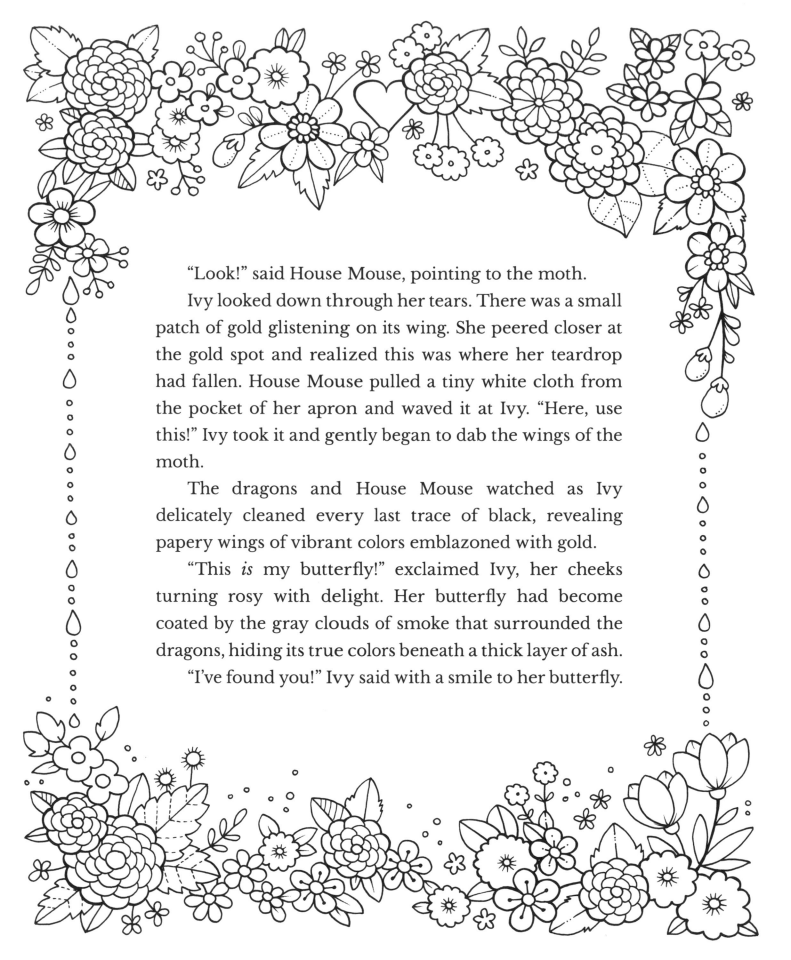

"Look!" said House Mouse, pointing to the moth.

Ivy looked down through her tears. There was a small patch of gold glistening on its wing. She peered closer at the gold spot and realized this was where her teardrop had fallen. House Mouse pulled a tiny white cloth from the pocket of her apron and waved it at Ivy. "Here, use this!" Ivy took it and gently began to dab the wings of the moth.

The dragons and House Mouse watched as Ivy delicately cleaned every last trace of black, revealing papery wings of vibrant colors emblazoned with gold.

"This *is* my butterfly!" exclaimed Ivy, her cheeks turning rosy with delight. Her butterfly had become coated by the gray clouds of smoke that surrounded the dragons, hiding its true colors beneath a thick layer of ash.

"I've found you!" Ivy said with a smile to her butterfly.

While Ivy admired the butterfly, a soot-covered moth fluttered down to join them. Using House Mouse's cloth, Ivy once again dabbed away the black on its wings to reveal another butterfly of the most dazzling colors and patterns. A second hidden treasure!

Ivy's beautiful butterfly and its colorful companion fluttered high above the banquet table and danced through the air in a joyful display of aerial acrobatics. "They look so happy!" exclaimed Ivy, delighted that her butterfly had finally found a friend.

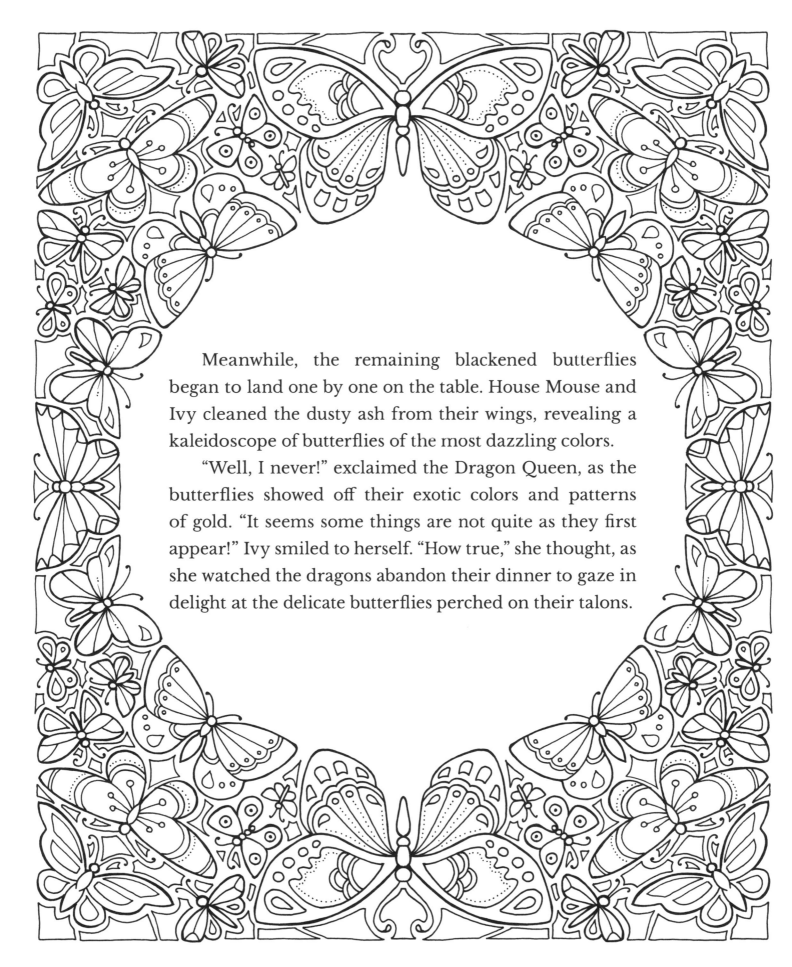

Meanwhile, the remaining blackened butterflies began to land one by one on the table. House Mouse and Ivy cleaned the dusty ash from their wings, revealing a kaleidoscope of butterflies of the most dazzling colors.

"Well, I never!" exclaimed the Dragon Queen, as the butterflies showed off their exotic colors and patterns of gold. "It seems some things are not quite as they first appear!" Ivy smiled to herself. "How true," she thought, as she watched the dragons abandon their dinner to gaze in delight at the delicate butterflies perched on their talons.

"What now?" asked House Mouse.

Ivy looked at her butterfly. It made her heart hurt to think of it all alone again. "Well, I found my butterfly, and it finally has a companion! I cannot bear to part them. I must go home, but I shall leave the butterfly here with its friend." She tried not to picture the empty picture frame or her grandfather's expression as she explained what had become of the butterfly it once contained.

As she spoke, the two butterflies floated down gently and landed on her hair like the most exquisite hair clasps.

The Dragon Queen laughed. "It would seem your butterflies have a different plan," she said with a chuckle.

It was time to go home.

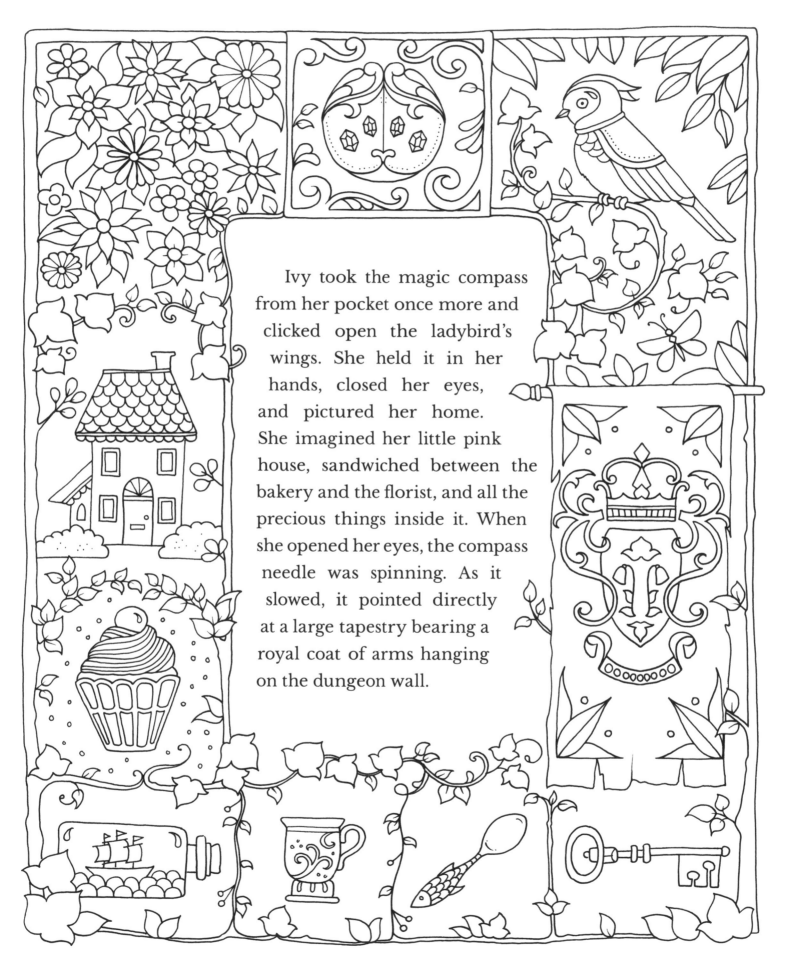

Ivy took the magic compass from her pocket once more and clicked open the ladybird's wings. She held it in her hands, closed her eyes, and pictured her home. She imagined her little pink house, sandwiched between the bakery and the florist, and all the precious things inside it. When she opened her eyes, the compass needle was spinning. As it slowed, it pointed directly at a large tapestry bearing a royal coat of arms hanging on the dungeon wall.

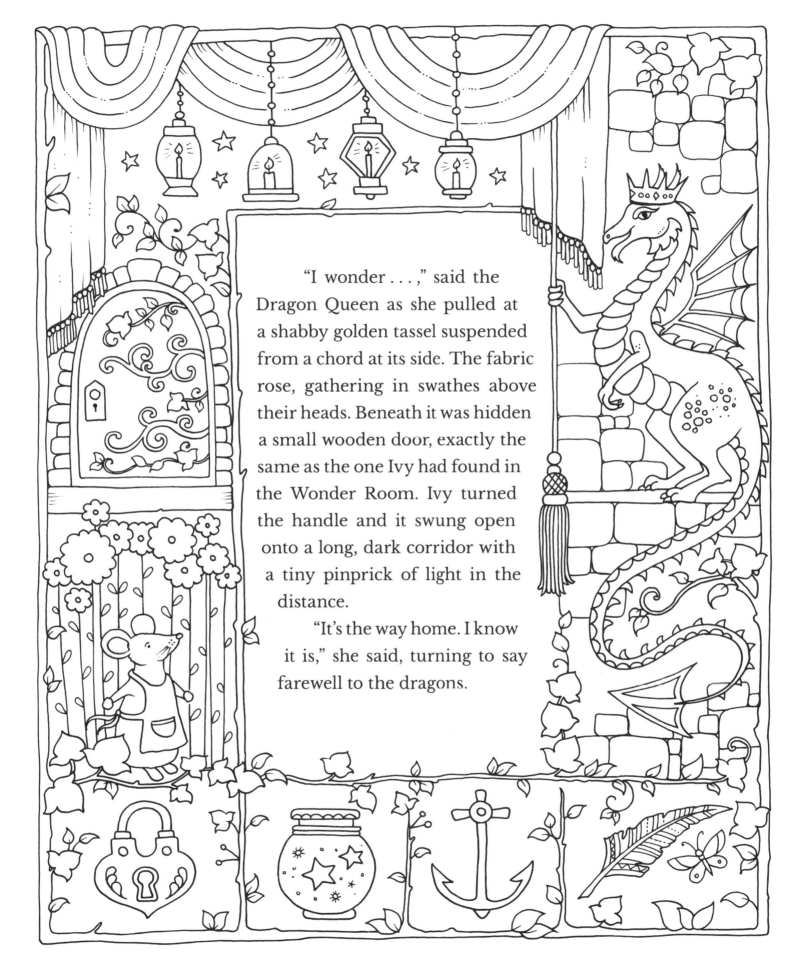

"I wonder . . . ," said the Dragon Queen as she pulled at a shabby golden tassel suspended from a chord at its side. The fabric rose, gathering in swathes above their heads. Beneath it was hidden a small wooden door, exactly the same as the one Ivy had found in the Wonder Room. Ivy turned the handle and it swung open onto a long, dark corridor with a tiny pinprick of light in the distance.

"It's the way home. I know it is," she said, turning to say farewell to the dragons.

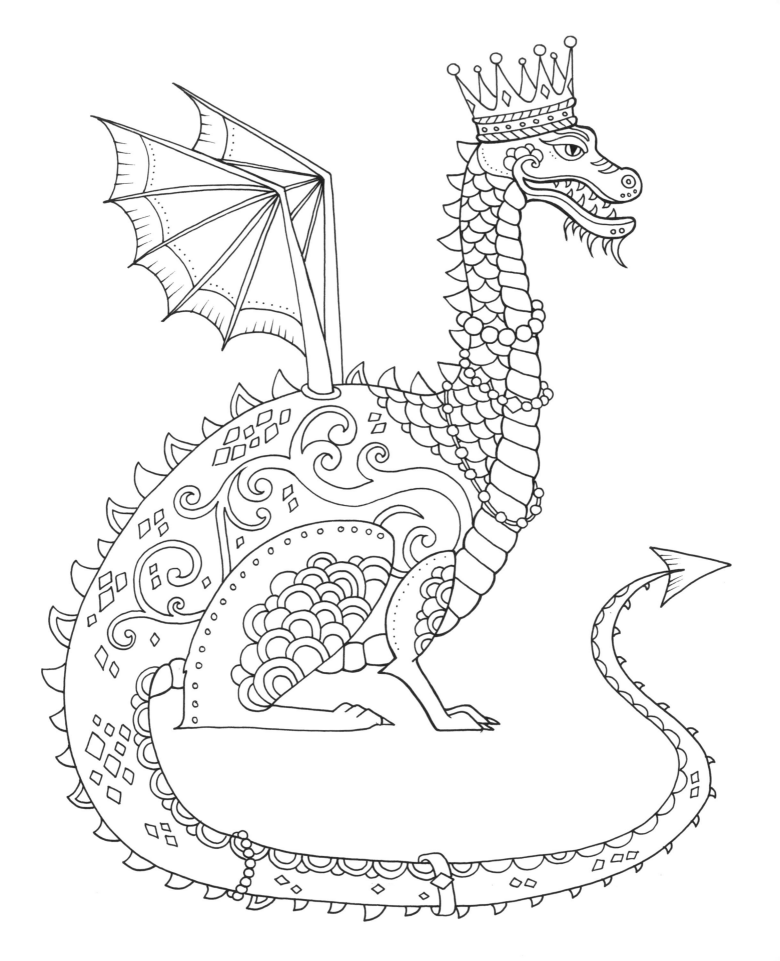

"Good-bye, little one," the Dragon Queen said, beaming, "and if you have any more marvelous adventures, do return to Enchantia and tell us the tale!" Ivy promised that she would.

Finally, Ivy turned to House Mouse. "How will you get back to your meadow?" she asked, realizing that House Mouse too was far from home. "Don't worry," said the Dragon Queen. "We'll take her home for you. But perhaps, House Mouse, you could help us clean the castle a little first?" she suggested, winking at the little mouse.

"Oh, it would be my pleasure!" squeaked House Mouse, truly delighted by the opportunity.

"Thank you so much for everything," Ivy whispered to House Mouse, knowing that she, like the butterfly, had found a special friend in this magical world. She gave the little mouse a hug and kissed her gently on the cheek. "I'll miss you," she said to her friend.

"I shall miss you too," replied House Mouse. "If ever you find yourself on another quest, I'd be delighted to be your companion again."

"I'd like that," smiled Ivy.

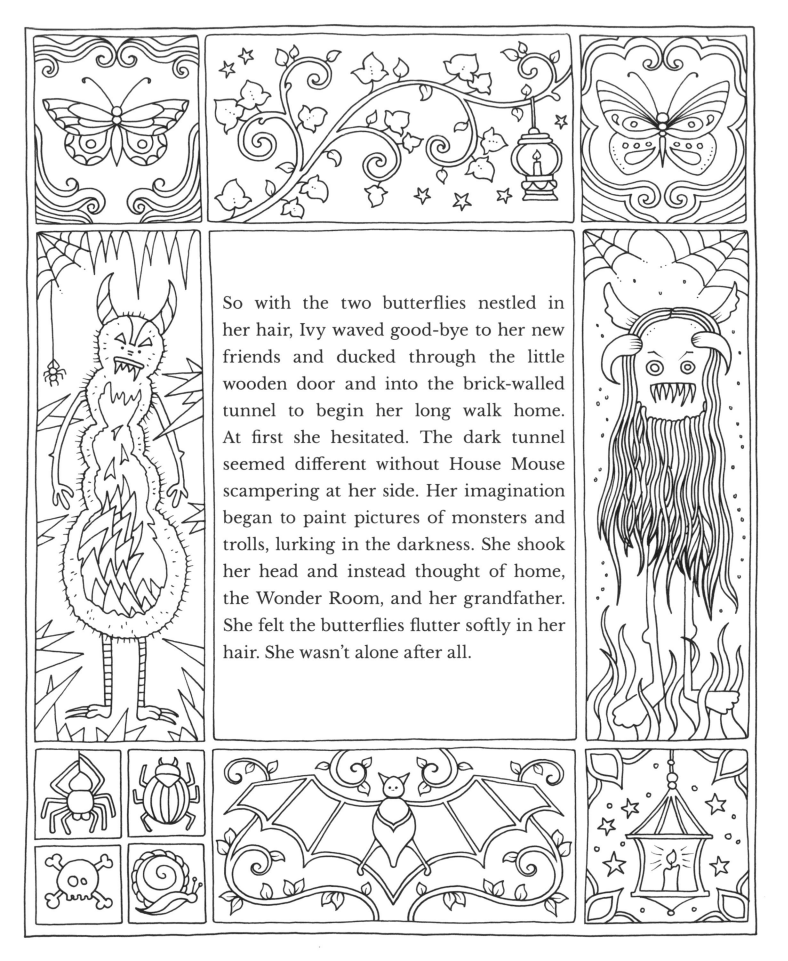

So with the two butterflies nestled in her hair, Ivy waved good-bye to her new friends and ducked through the little wooden door and into the brick-walled tunnel to begin her long walk home. At first she hesitated. The dark tunnel seemed different without House Mouse scampering at her side. Her imagination began to paint pictures of monsters and trolls, lurking in the darkness. She shook her head and instead thought of home, the Wonder Room, and her grandfather. She felt the butterflies flutter softly in her hair. She wasn't alone after all.

Very slowly, the tiny spot of light at the end of tunnel began to appear closer. As she neared the end of the tunnel, Ivy could make out items of furniture: a table; a large, tall cabinet; a lamp perhaps? A smile crept across her face. She recognized those things! It was the Wonder Room.

With her home now in sight, Ivy ran the last few steps, squeezed through a small square opening at the mouth of the tunnel, and tumbled headfirst into the Wonder Room. She lay on the hearth rug and looked around to see where she had come from. It was the fireplace! She glanced over to the bookcase and, to her surprise, saw all the books were stacked neatly on shelves again.

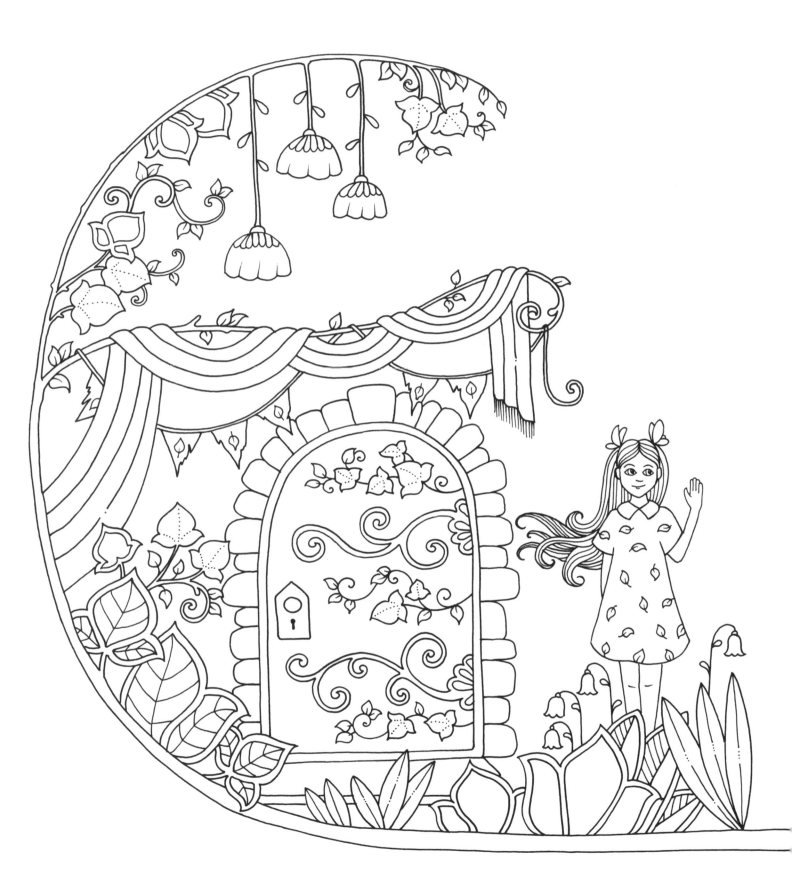

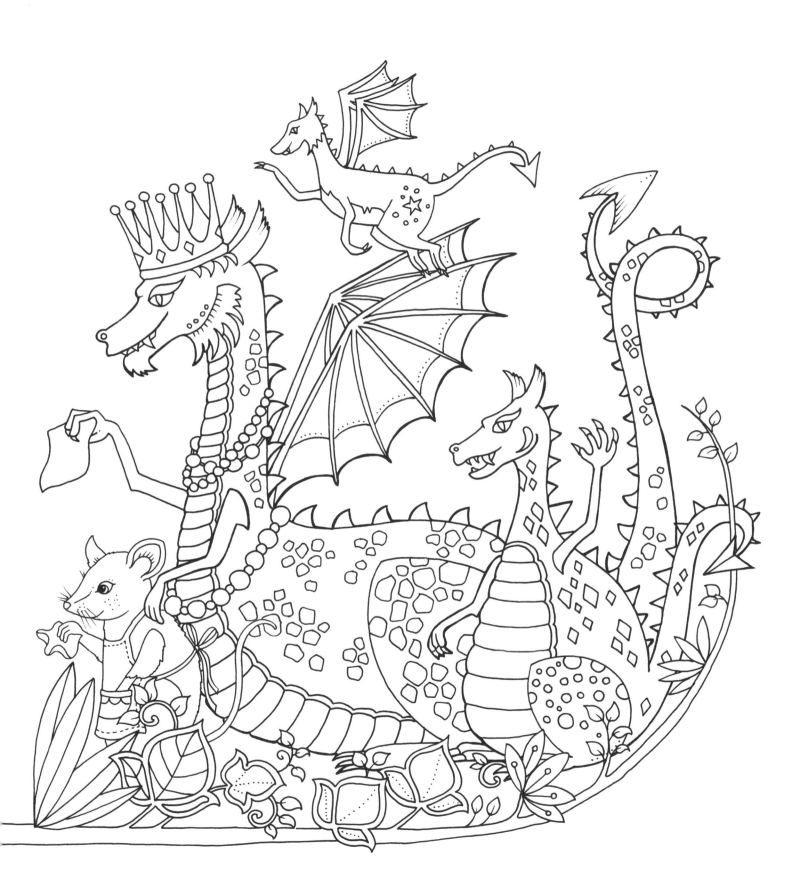

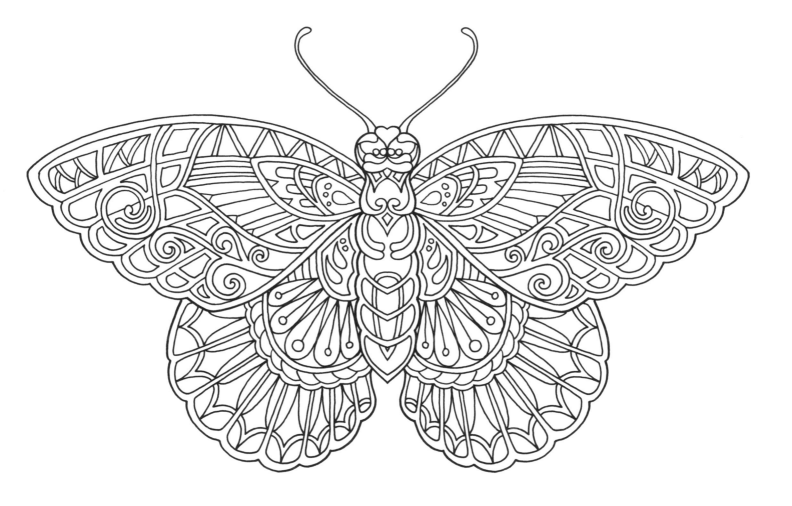

Ivy felt the butterflies' wings flutter to life in her hair. They flew up into the air above her and danced another merry ballet, spiraling around each other in midair. Then, quite without warning, they flew toward the empty picture frame hanging on the wall. As they neared the frame, there was a sudden golden flash. Ivy rubbed the stars from her eyes, eager to see what had happened. The beautiful butterfly was a painting once more, but now there was something different.

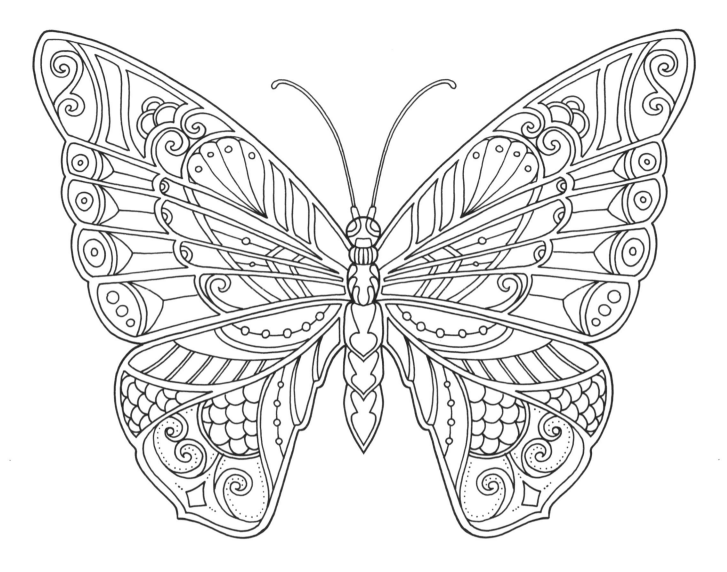

She climbed onto a chair and scrutinized the painting in disbelief. Sure enough, it depicted not one but *two* beautiful butterflies, perfectly positioned within the large frame, as if they had always been there. So much so, in fact, that a tiny seedling of doubt sprouted in her mind. *Had* she imagined her adventures? The secret doors? The journey? House Mouse and Pica and the woodland elves and the dragons? *Had* there always been two butterflies in that painting?

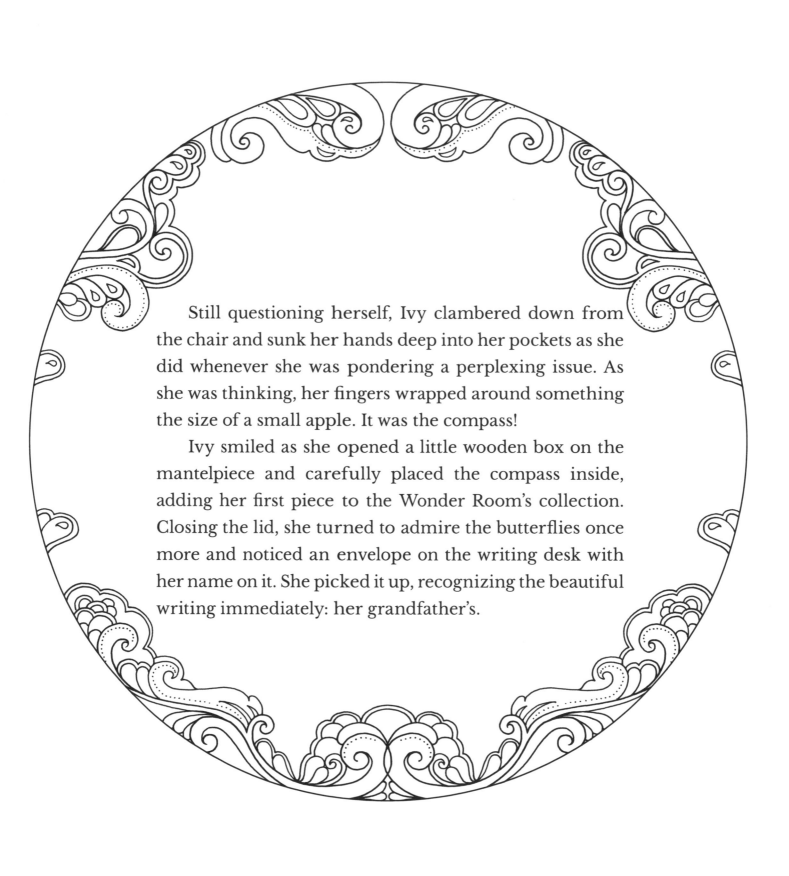

Still questioning herself, Ivy clambered down from the chair and sunk her hands deep into her pockets as she did whenever she was pondering a perplexing issue. As she was thinking, her fingers wrapped around something the size of a small apple. It was the compass!

Ivy smiled as she opened a little wooden box on the mantelpiece and carefully placed the compass inside, adding her first piece to the Wonder Room's collection. Closing the lid, she turned to admire the butterflies once more and noticed an envelope on the writing desk with her name on it. She picked it up, recognizing the beautiful writing immediately: her grandfather's.

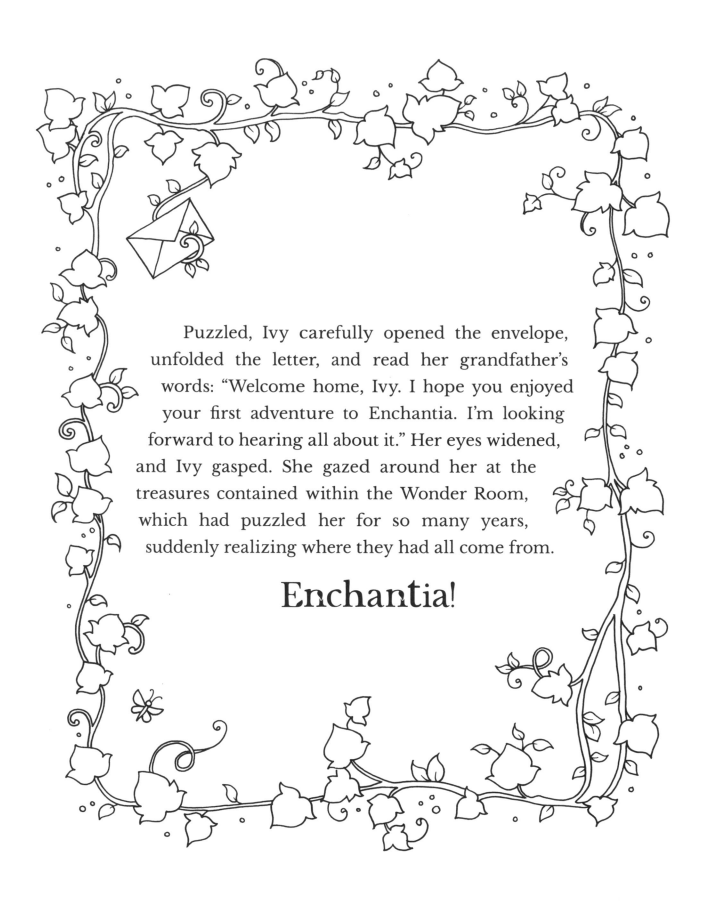

Puzzled, Ivy carefully opened the envelope, unfolded the letter, and read her grandfather's words: "Welcome home, Ivy. I hope you enjoyed your first adventure to Enchantia. I'm looking forward to hearing all about it." Her eyes widened, and Ivy gasped. She gazed around her at the treasures contained within the Wonder Room, which had puzzled her for so many years, suddenly realizing where they had all come from.

Enchantia!

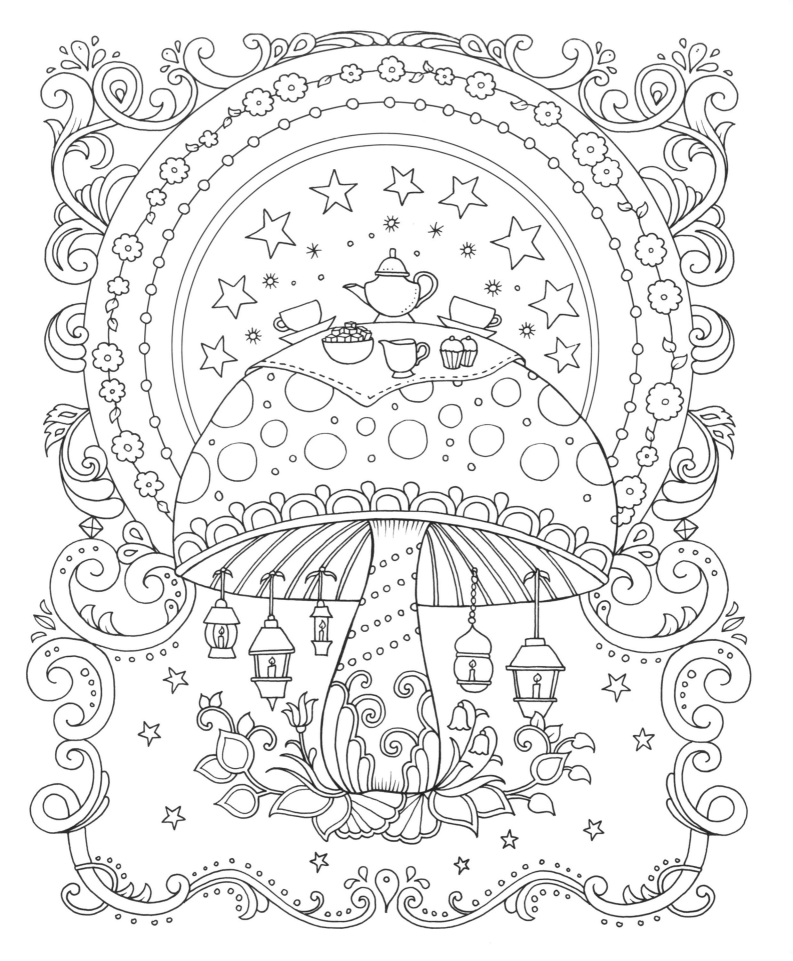

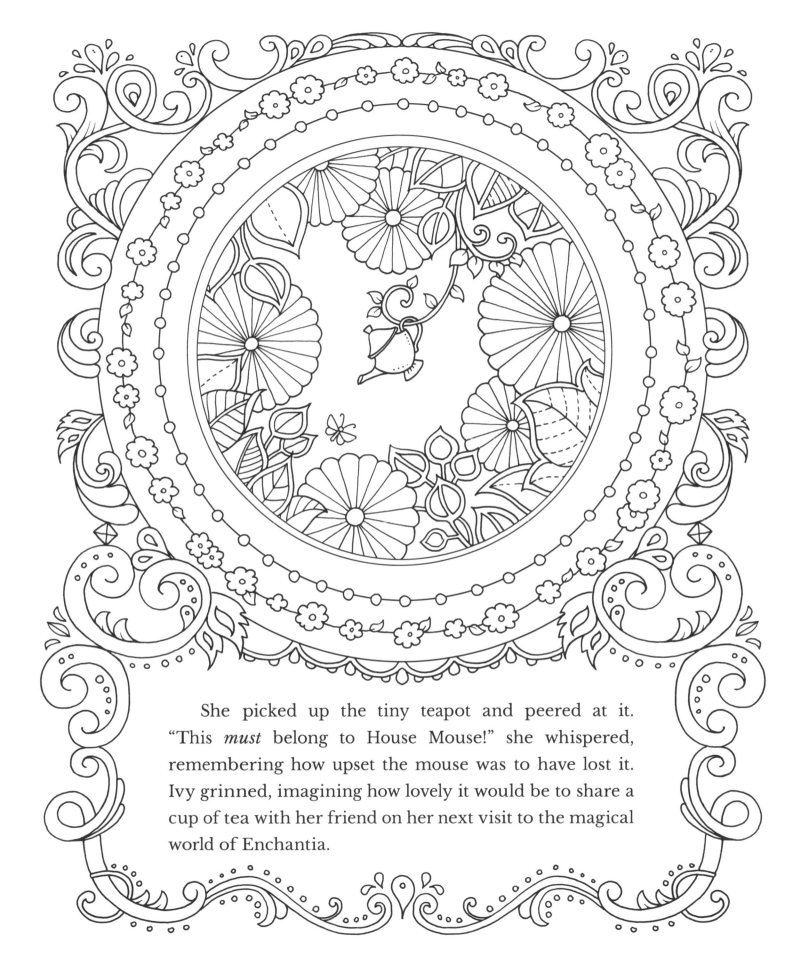

She picked up the tiny teapot and peered at it. "This *must* belong to House Mouse!" she whispered, remembering how upset the mouse was to have lost it. Ivy grinned, imagining how lovely it would be to share a cup of tea with her friend on her next visit to the magical world of Enchantia.

The End

PENGUIN BOOKS

An imprint of Penguin Random House LLC
375 Hudson Street
New York, New York 10014
penguin.com

ISBN 9780143130925

Printed in China
5 7 9 10 8 6 4

Interior designed by Johanna Basford
and Sabrina Bowers

Color Palette Test Page

Color Palette Test Page